SPRING VISITS

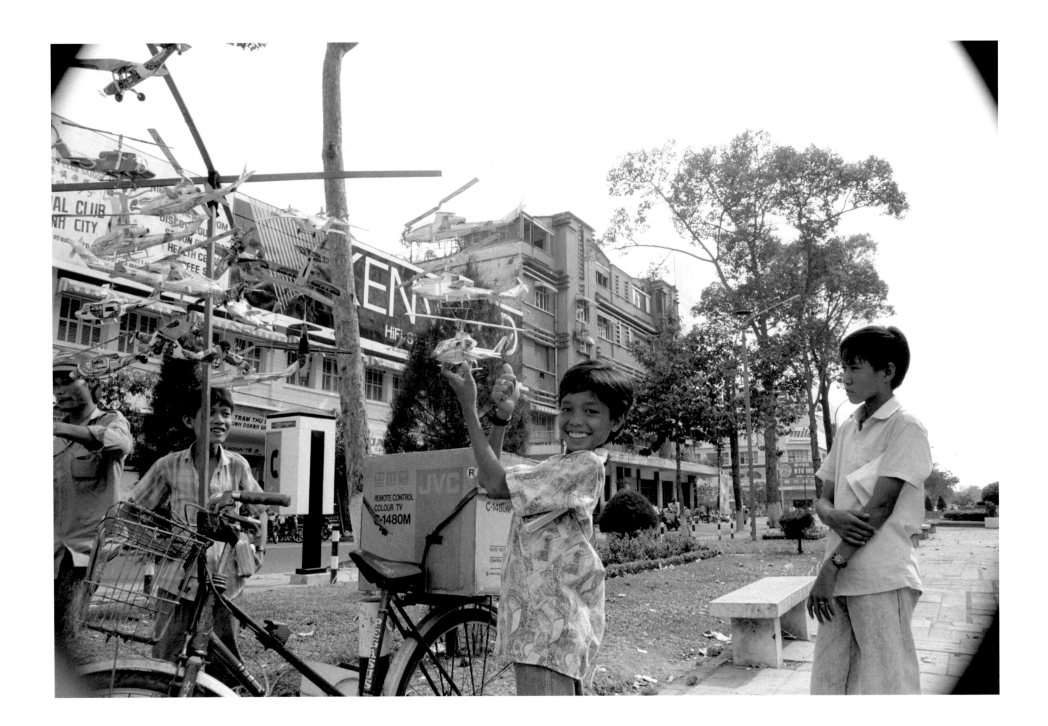

spring visits

PHOTOGRAPHS FROM VIET NAM

Don Unrau

STRAY DOG PRESS

For My Parents

Spring-Watching Pavilion

A gentle spring evening arrives

airily, unclouded by worldly dust.

Three times the bell tolls echoes like a wave.

We see heaven upside-down in sad puddles.

Love's vast sea cannot be emptied.

And springs of grace flow easily everywhere.

Where is nirvana?

Nirvana is here, nine times out of ten.

Ho Xuan Huong

DURING THE EARLY 1970'S, as America's aspirations in Viet Nam began the somber and certain outcome, I was afforded the opportunity to study art and photography under the G.I. Bill. This chance to reframe my personal reference to Viet Nam came long after the grainy image of a solitary helicopter, weighted with failed ambitions, departed heavily from a Saigon rooftop. When I returned for the first time with a camera in 1992, Saigon had become Ho Chi Minh City, a place with it's own brand of hustle.

That first spring visit came long after joining in America's war against the unknown. It was during a disconnected time when I found looking through the camera viewfinder a helpful undertaking. Clear streams of consciousness were connecting to this crazy realm encountered light years before as an idealistic, unknowing, twenty-one year old soldier.

For more than one generation of Americans, we are reminded of this bizarre and insane terrain. We became familiar with the places that our fathers, husbands, sons, daughters and classmates marched off to. And for all who went with hearts and minds of youth, who were afraid and still courageous, most served out of obligation; though many went with objection in this time and place. Even as we reconcile what has changed, much of it quietly remains . . . the writings, the films, the music, the images, and the smells. All those things persist and are carried with us, including the names . . . theirs and ours.

SPRING VISITS

1 ▾ HELICOPTERS, HO CHI MINH CITY, 1992

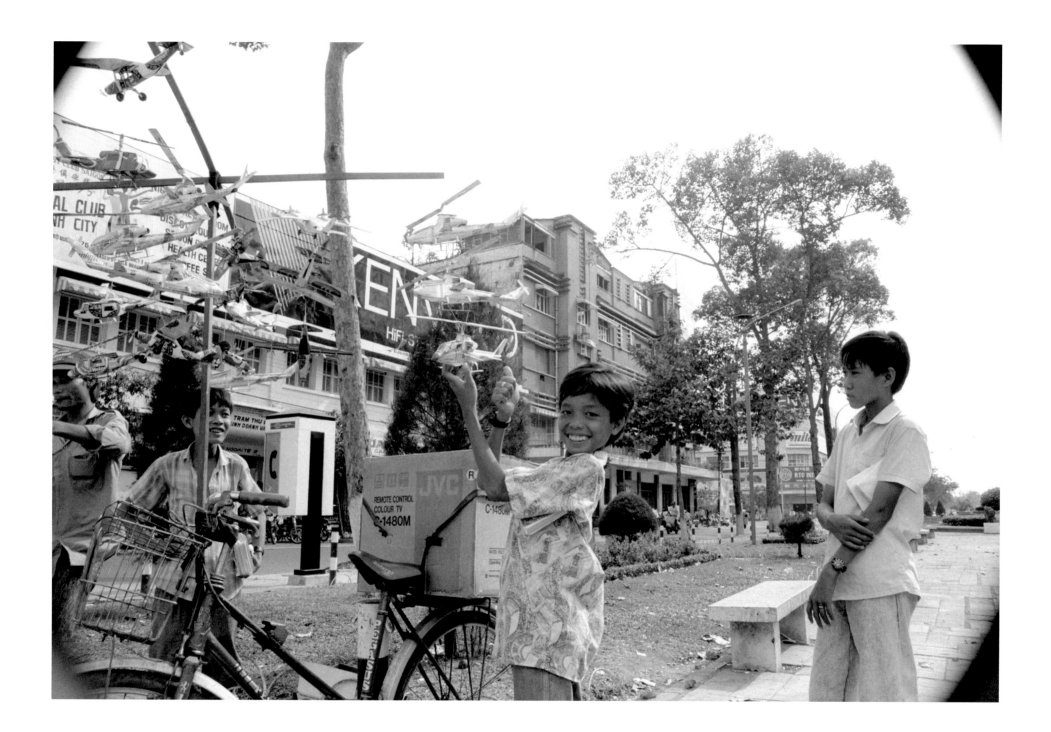

2 ▾ MONUMENT, HO CHI MINH CITY, 2004

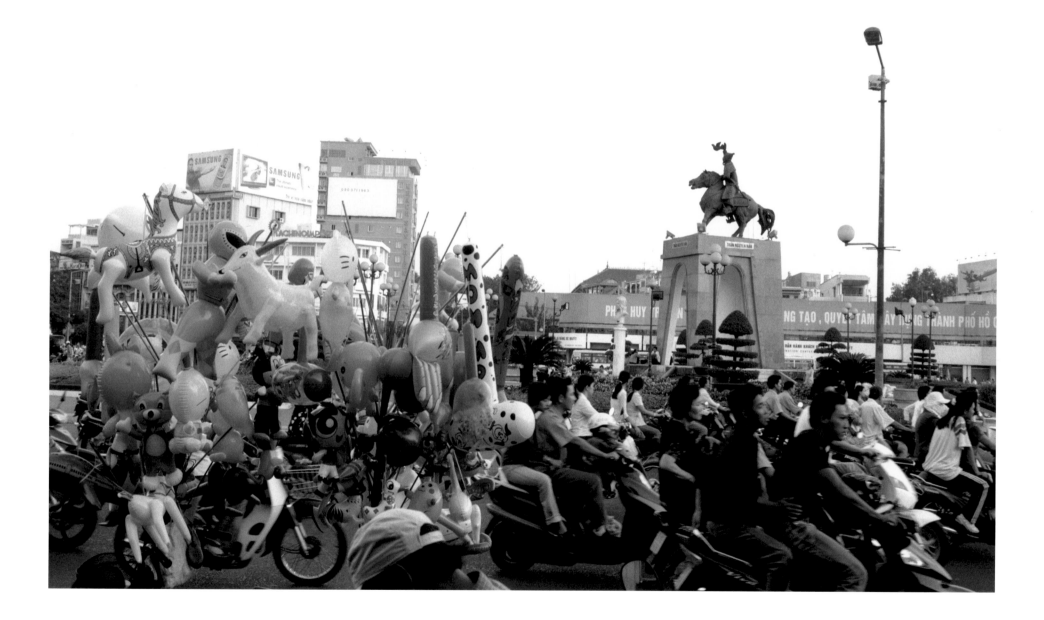

3 ▾ MOTORBIKE REPAIR, HO CHI MINH CITY, 1992

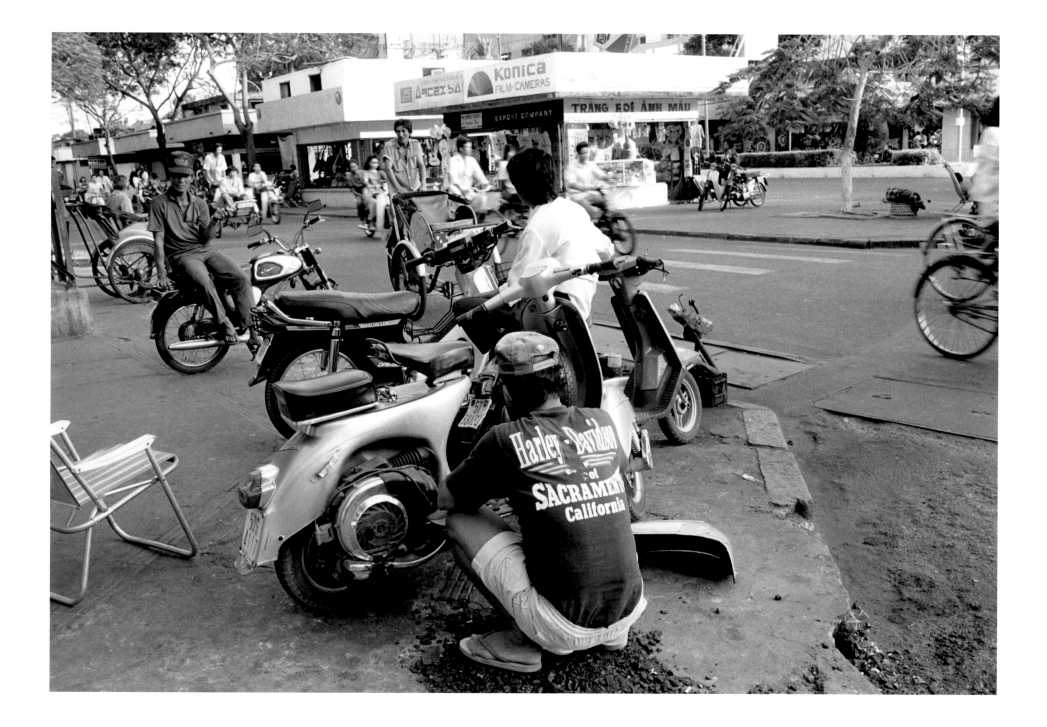

4 ▾ DE THAM STREET, HO CHI MINH CITY, 2000

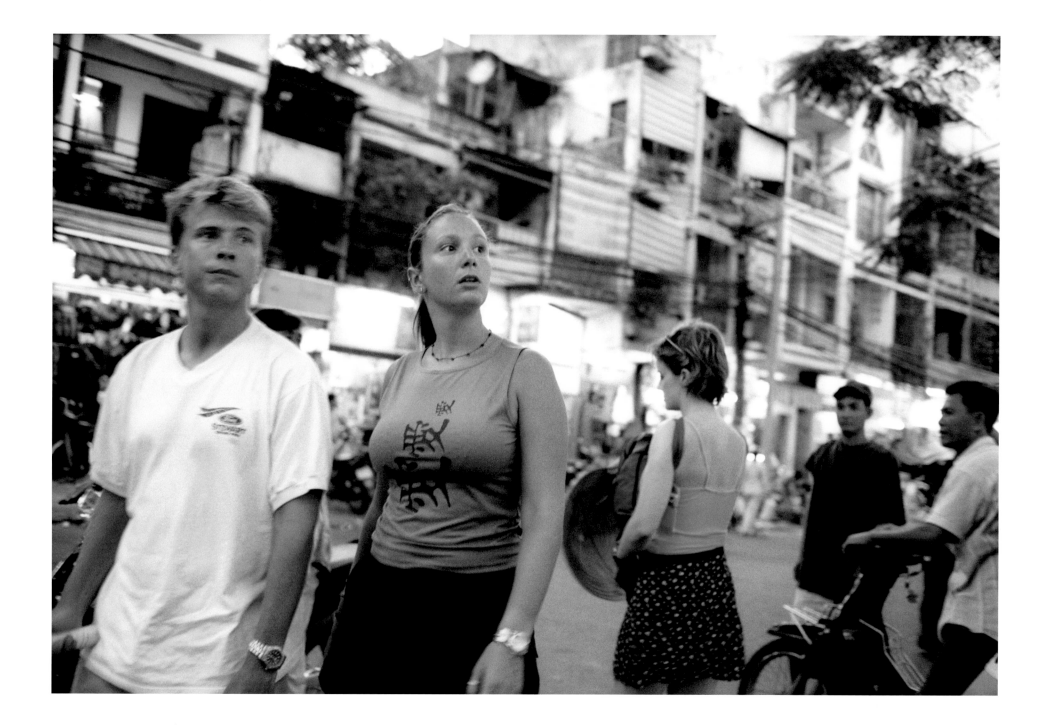

5 ▾ RACE IN THE PARK, HO CHI MINH CITY, 2004

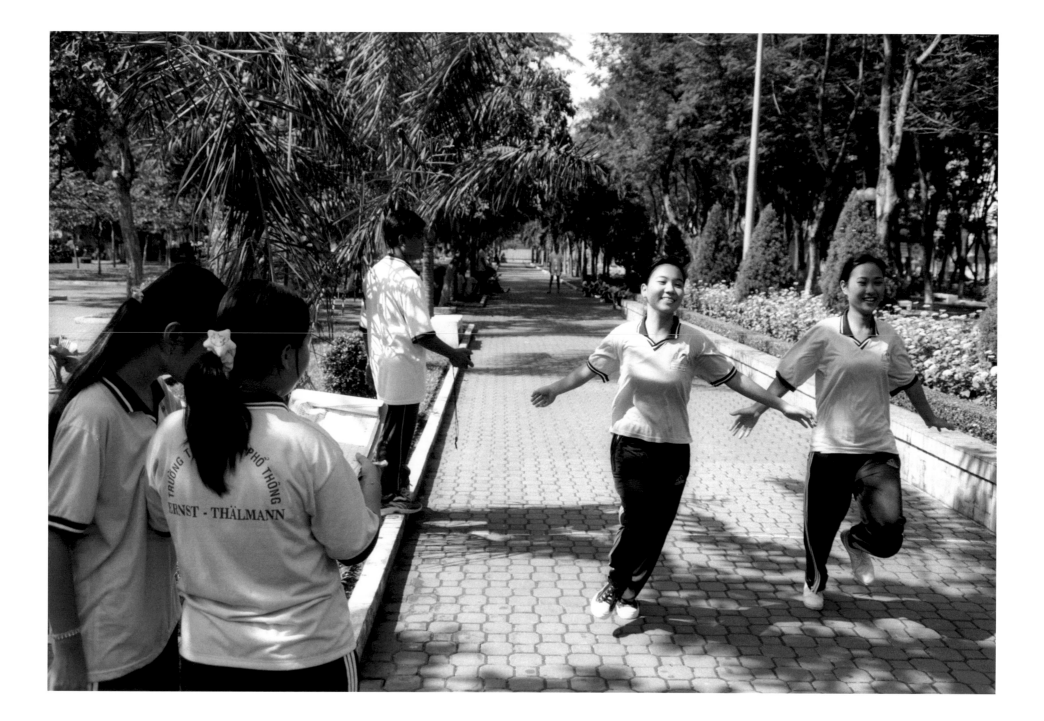

6 ▾ TENNIS LESSON, HO CHI MINH CITY, 1992

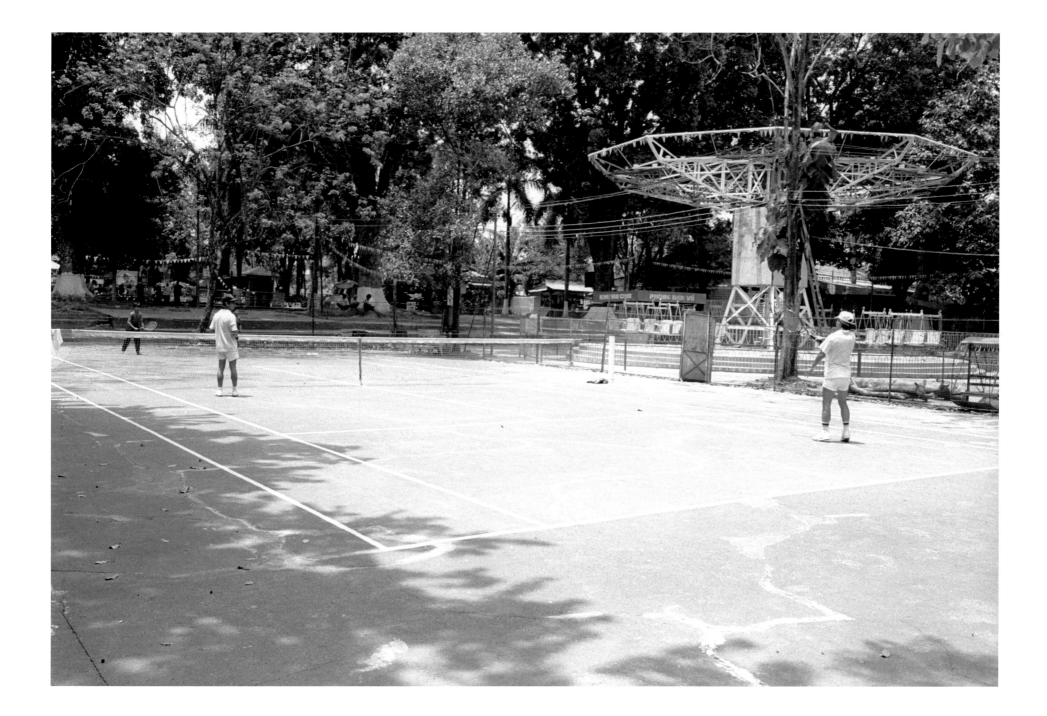

7 ▾ INTERSECTION, HO CHI MINH CITY, 2005

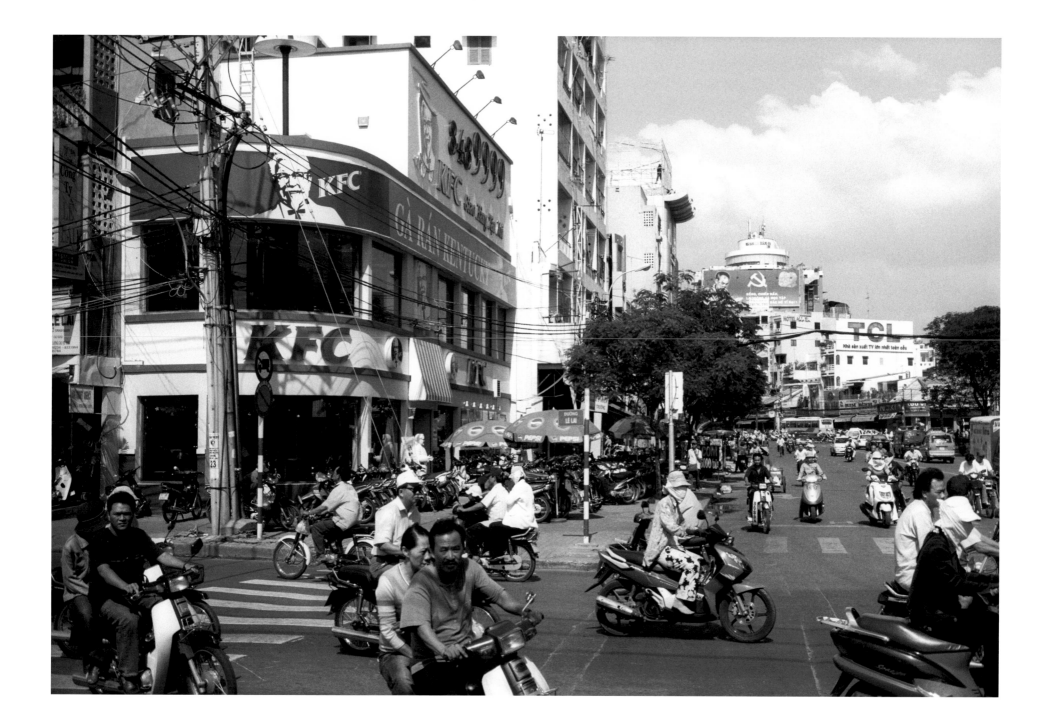

8 ▾ NORTH POLE, HO CHI MINH CITY, 2005

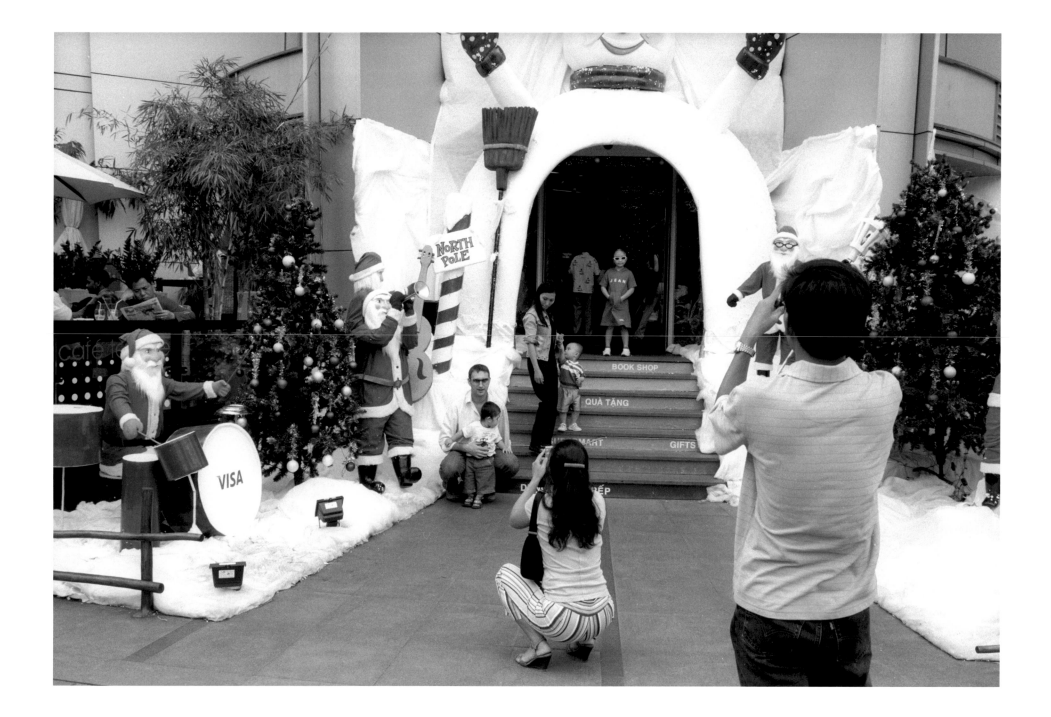

9 ▾ MACHINE SHOP, HO CHI MINH CITY, 2004

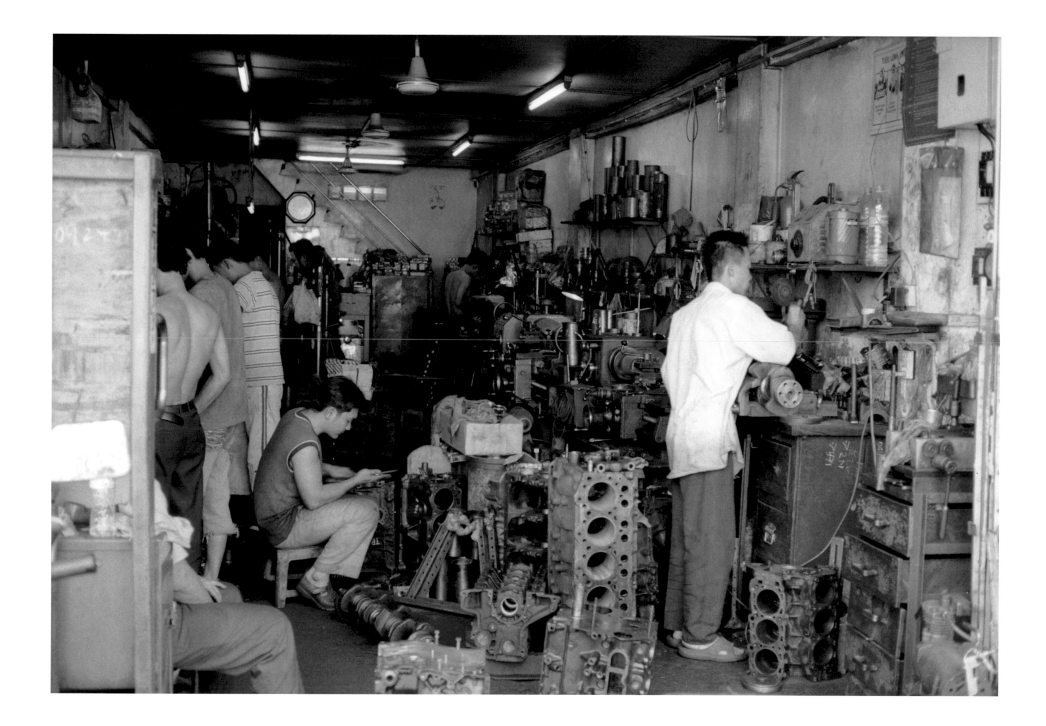

10 ▾ CAFE WALL, HO CHI MINH CITY, 2000

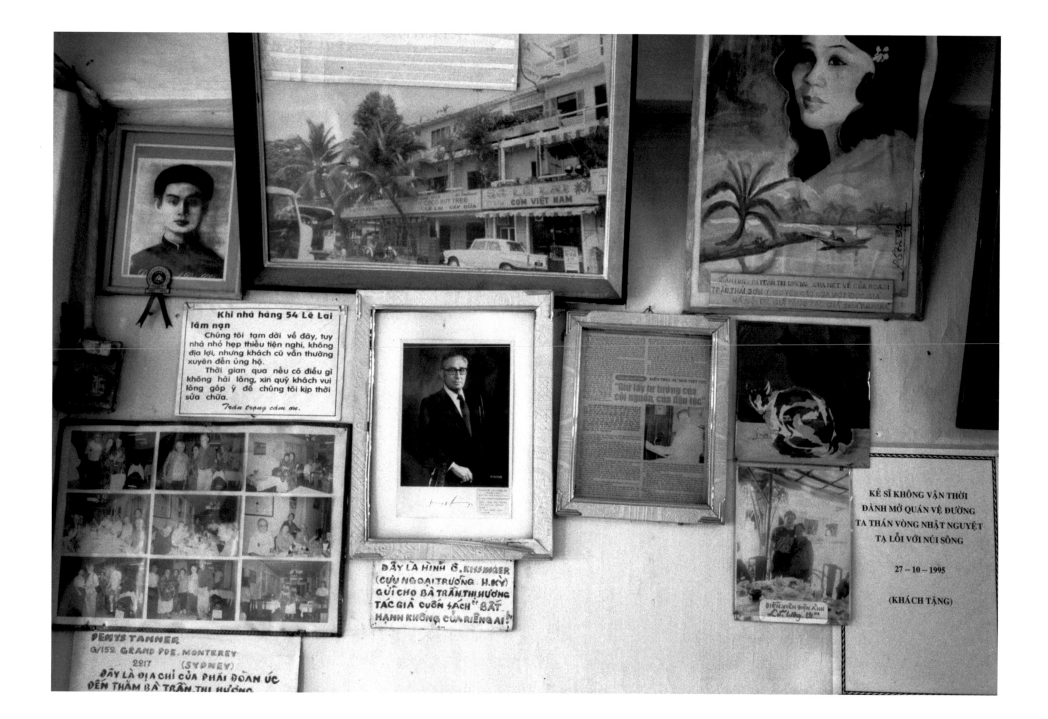

11 ▾ VUNG TAU, 1992

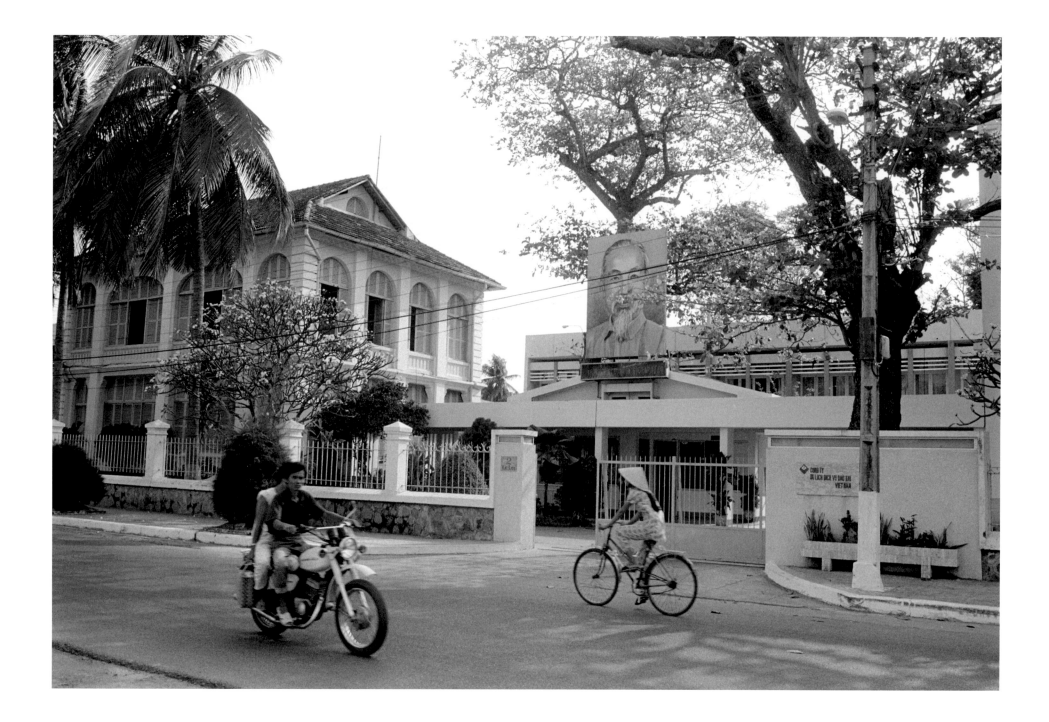

12 ▾ GUM AND CIGARETTES, VUNG TAU, 1992

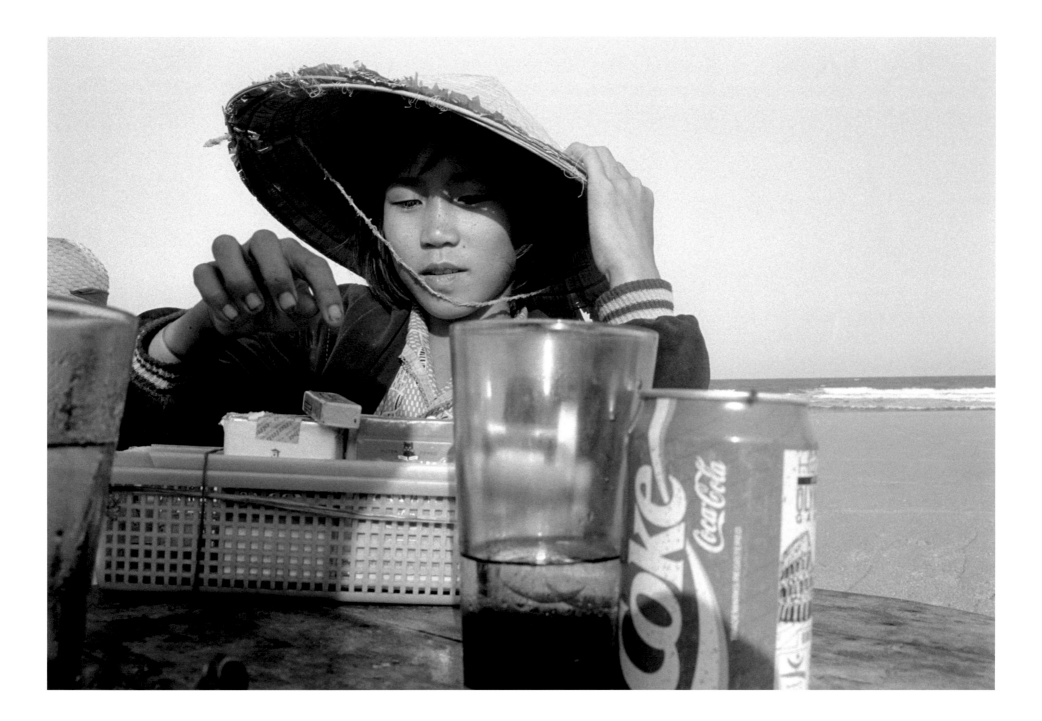

13 ▾ WOMAN AND BASKET, 1992

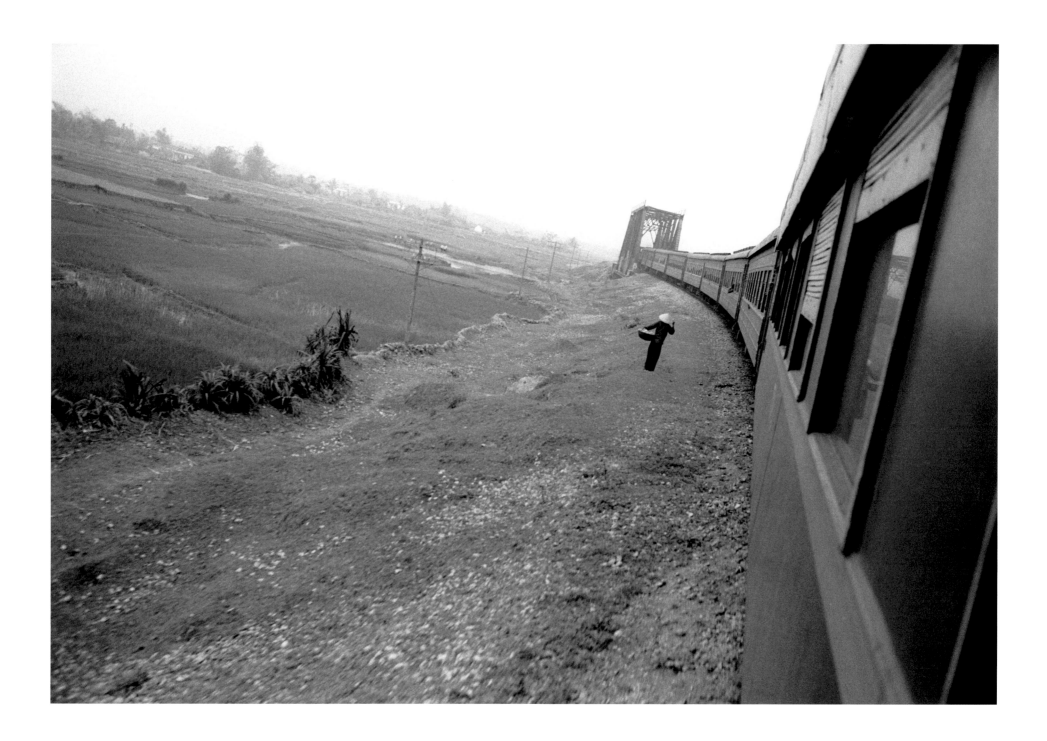

14 ▾ TRAIN TO HA NOI, 1992

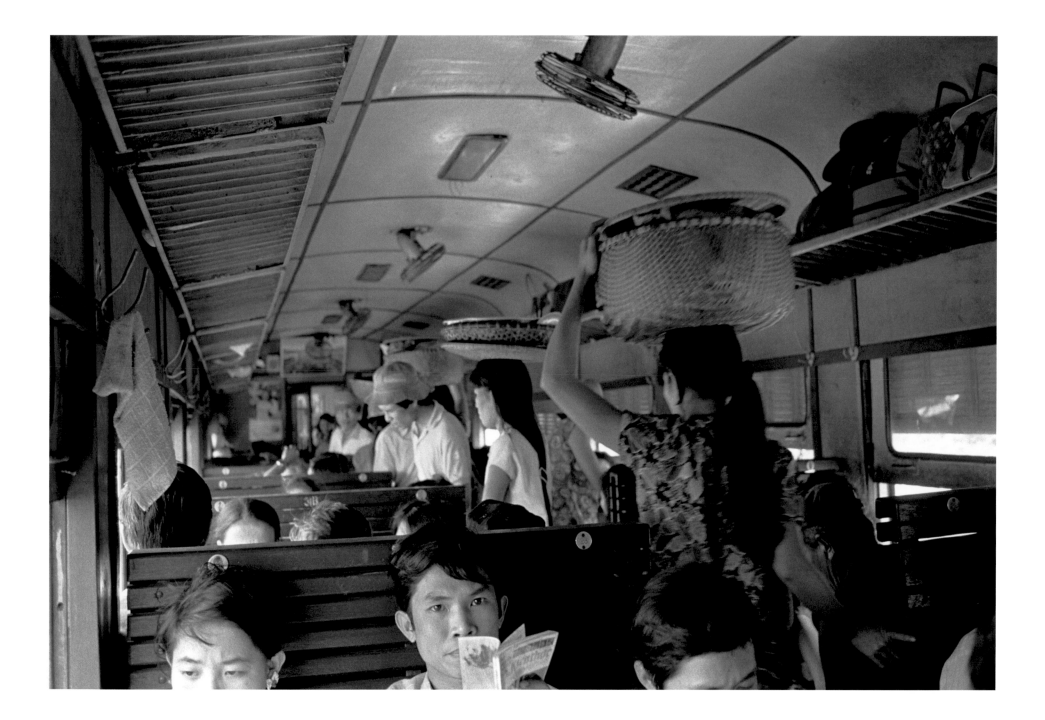

15 ▾ BOY WITH ROOSTERS, 1992

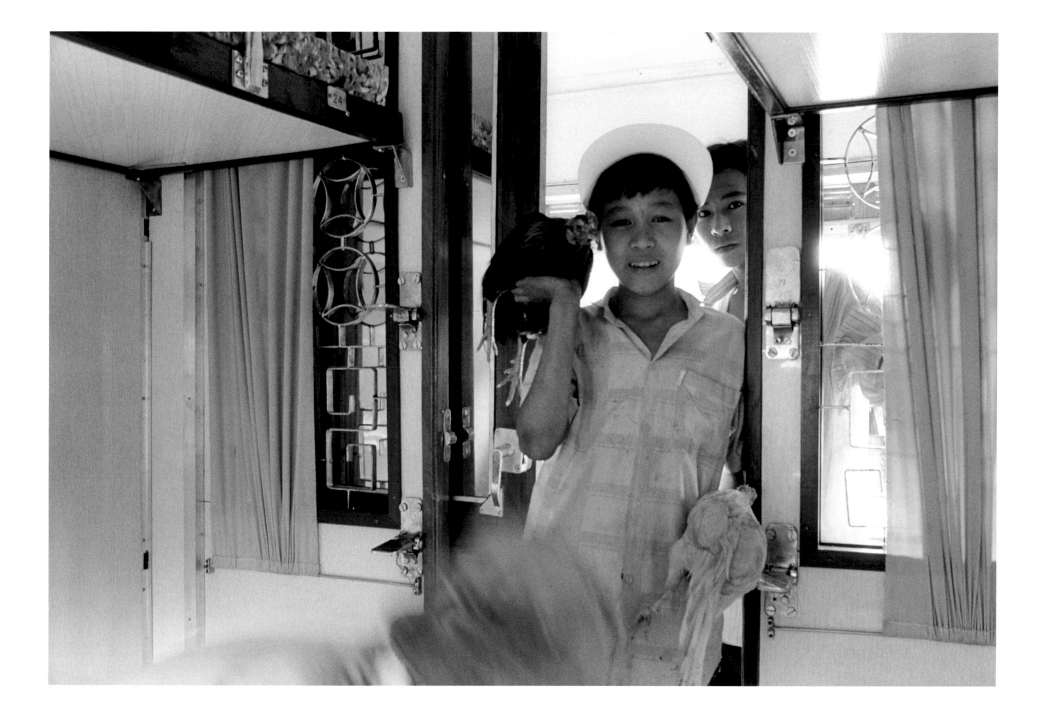

16 ▾ PASSING TRAIN, 1992

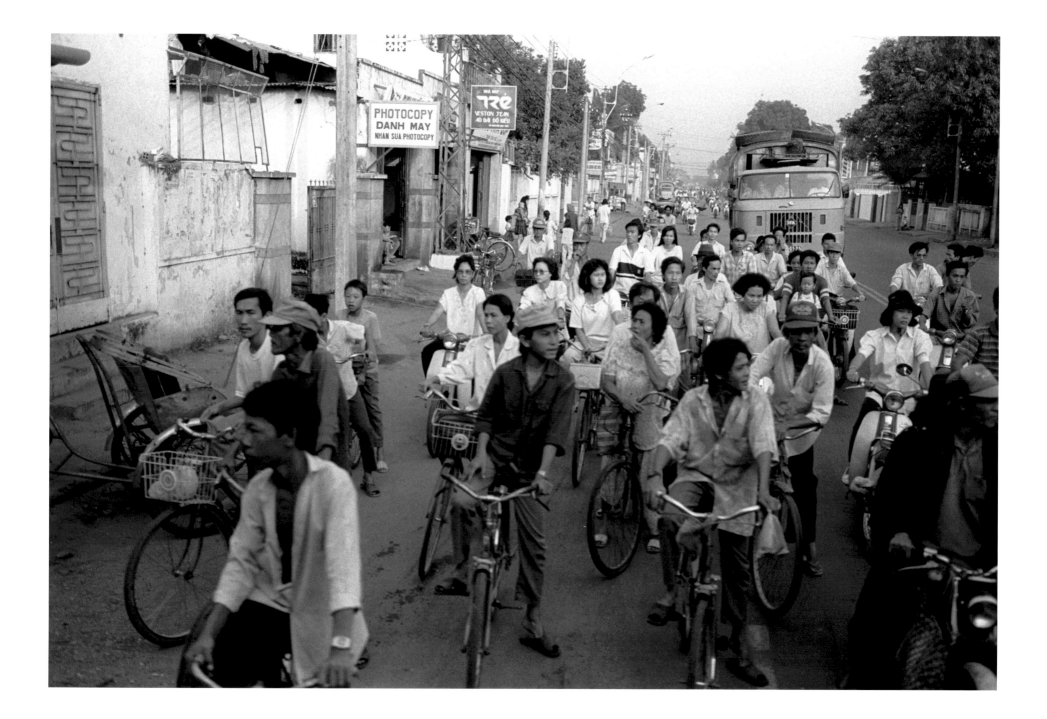

17 ▾ PEOPLE'S ARMY, PHU BAI, 1992

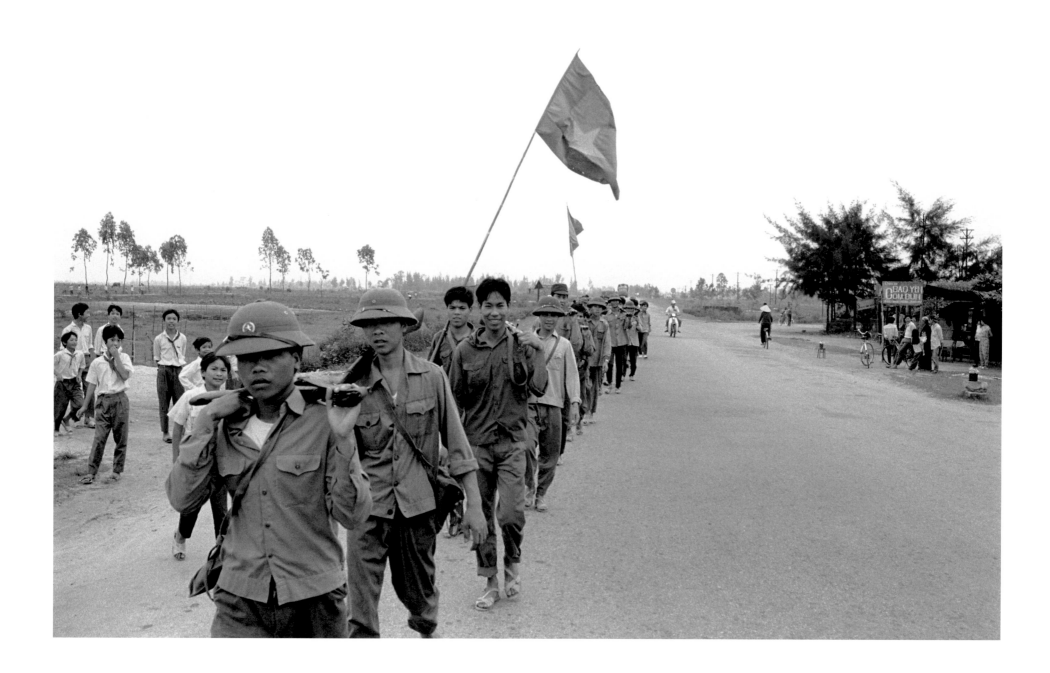

18 ▾ RECLINING VIET CONG, 2004

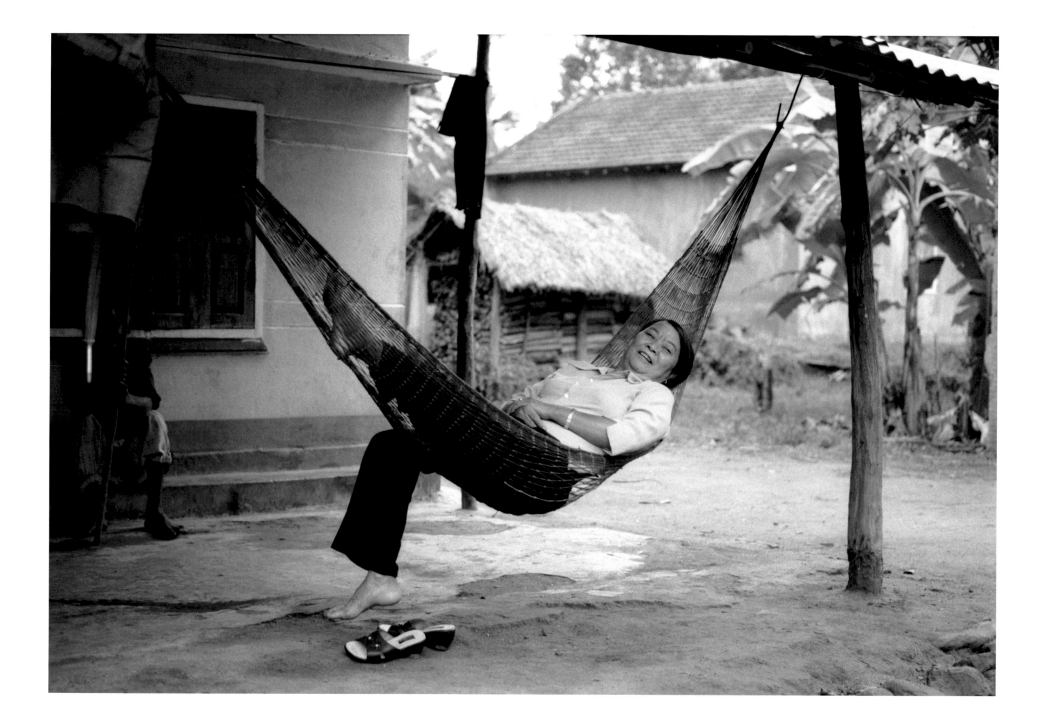

19 ▾ MOUNTAIN VILLAGE, 2004

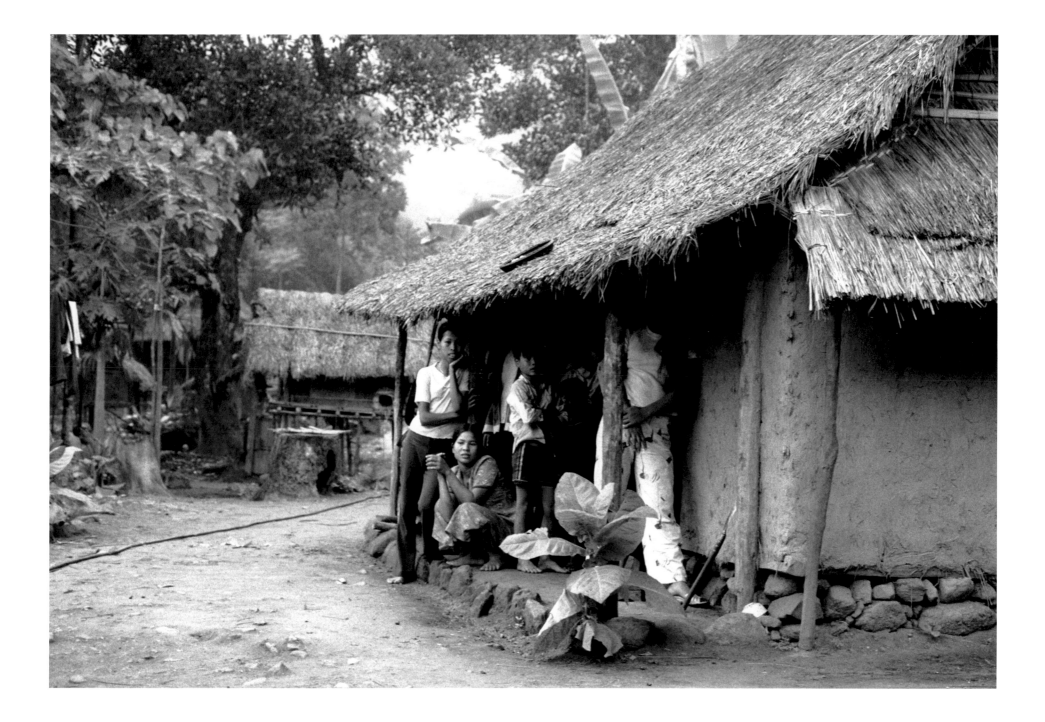

20 ▾ FAMILY DEATH SITE, MY LAI, 1992

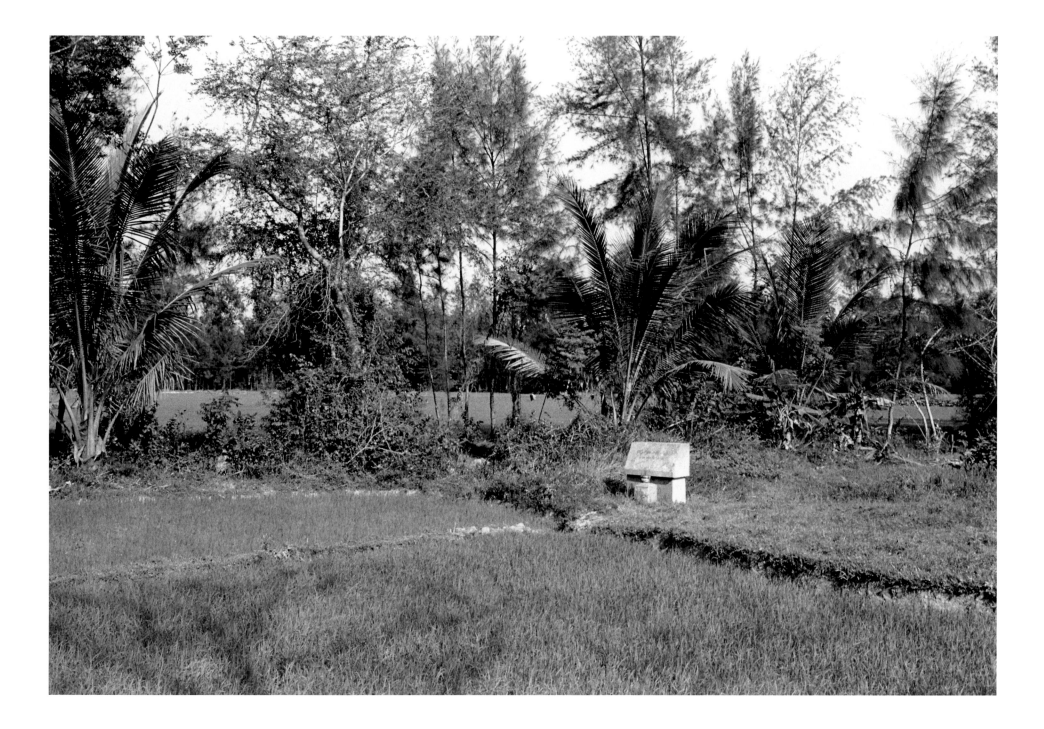

21 ▾ MUSEUM, MY LAI, 2000

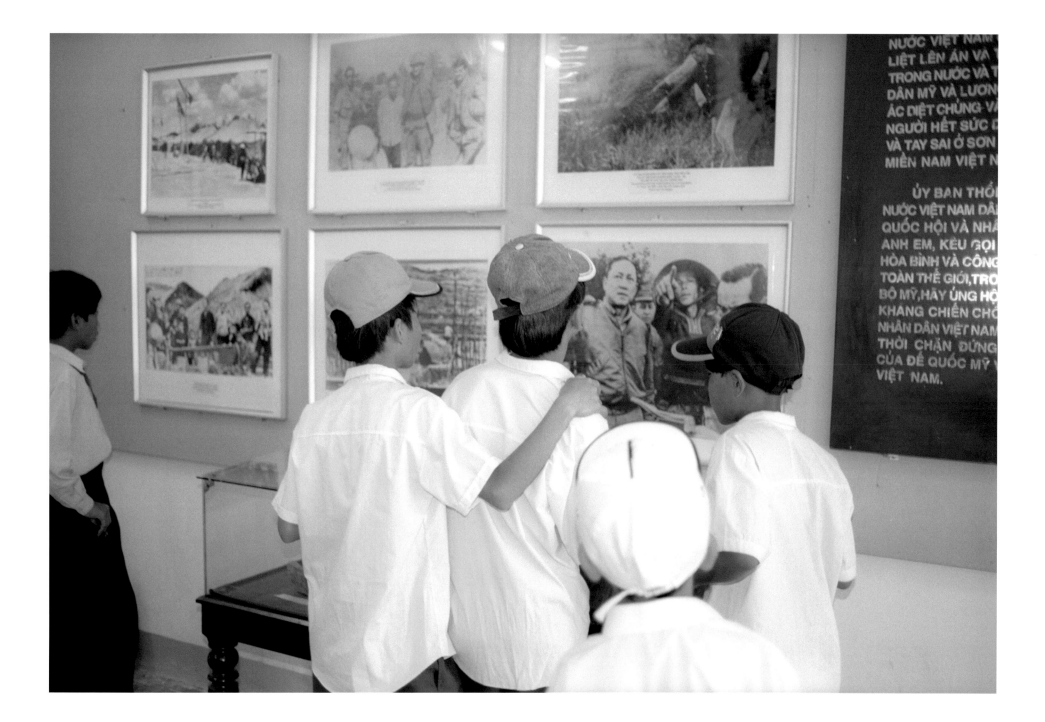

22 ▾ PEACEFUL PLACE, 2004

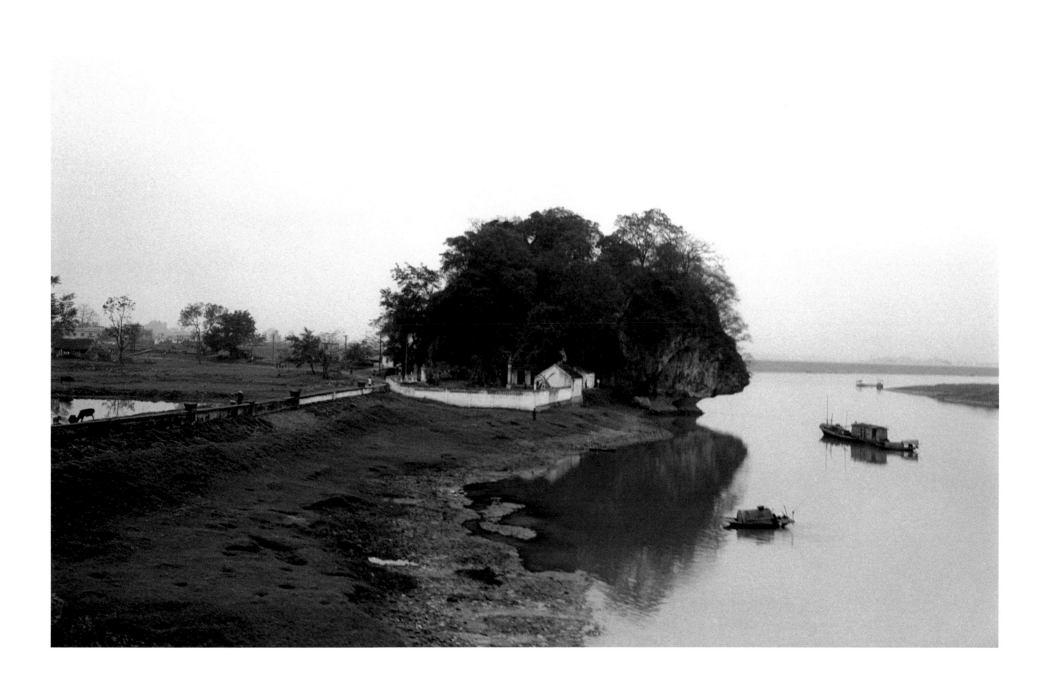

23 ▾ MORNING LABOR, QUANG NGAI, 2004

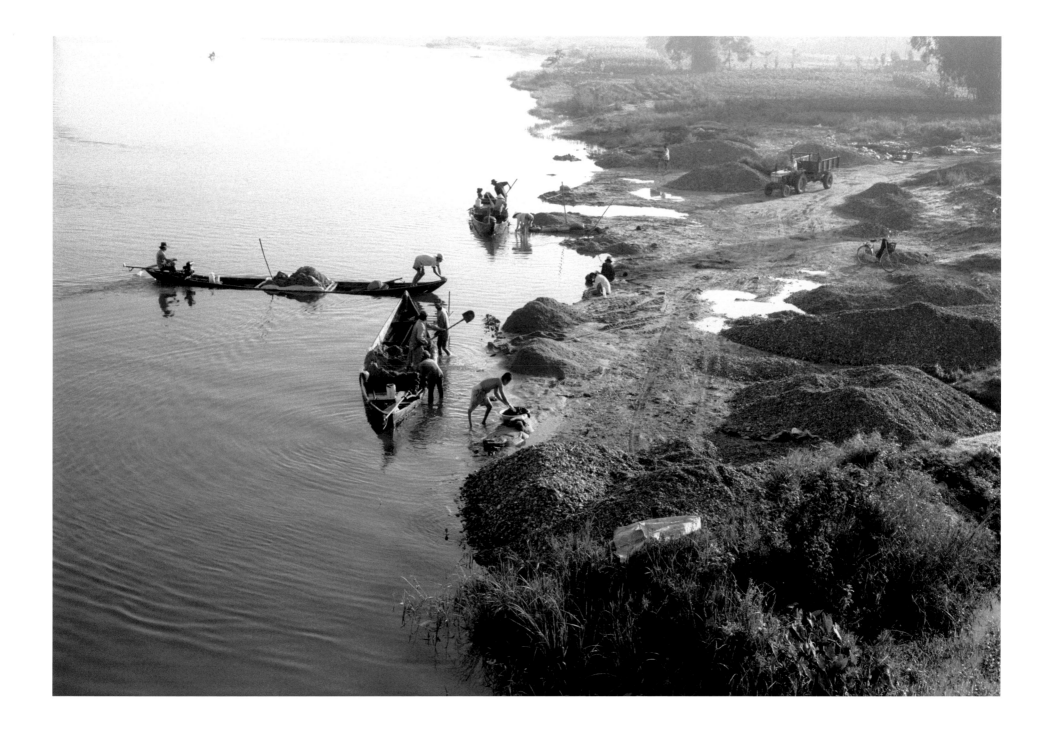

24 ▾ MOUNTAIN ROAD, QUANG NGAI, 2004

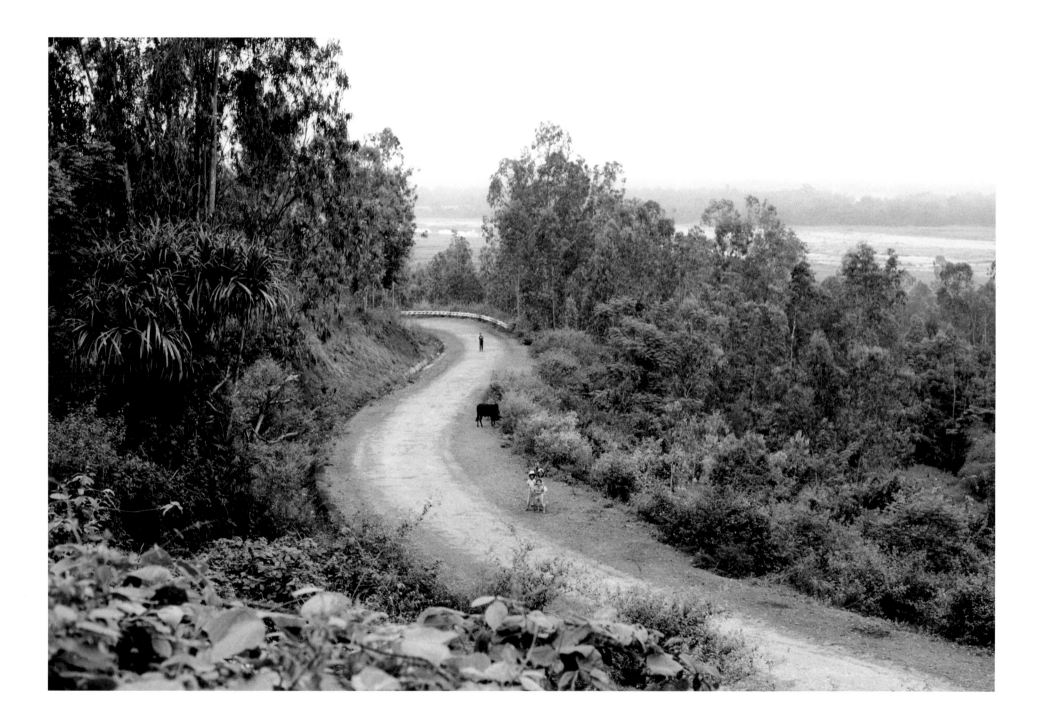

25 ▾ HAI VAN (SEA CLOUD) PASS, 2004

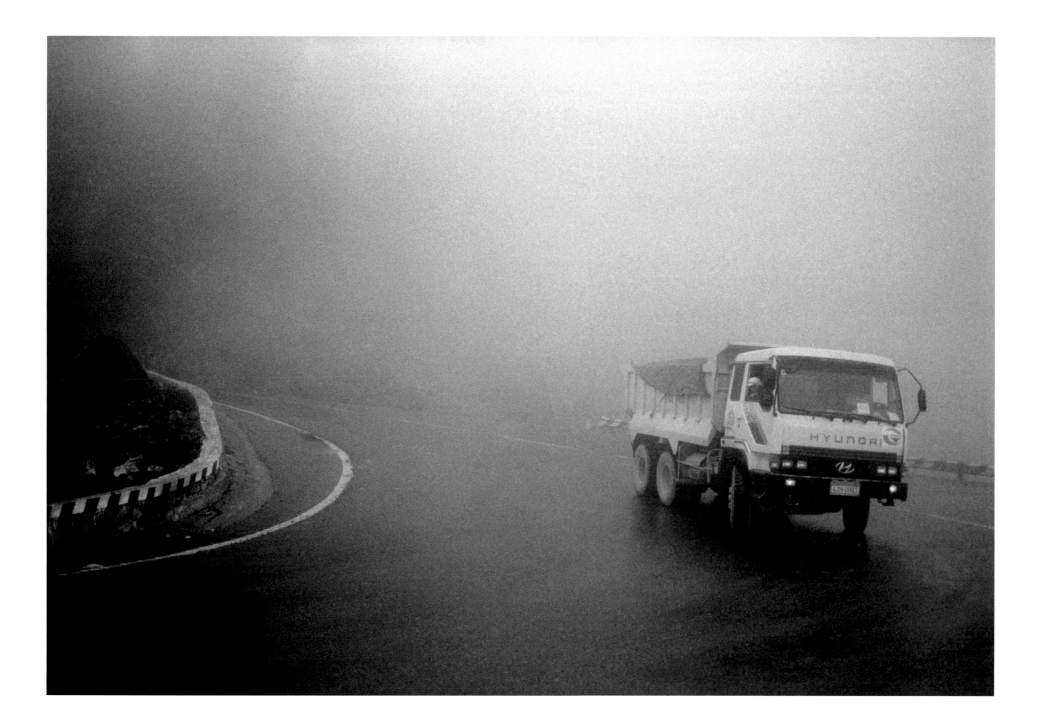

26 ▾ EARLY MORNING BADMITTEN, NHA TRANG, 2000

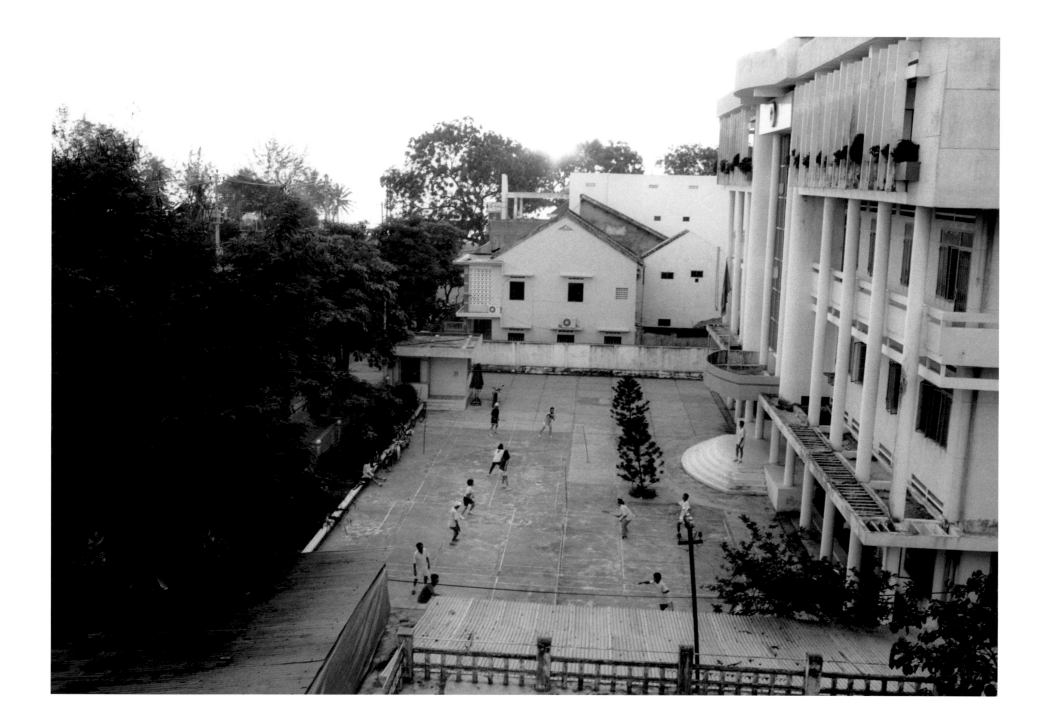

27 ▾　THE WHITE DRESS, XUAN LOC, 1992

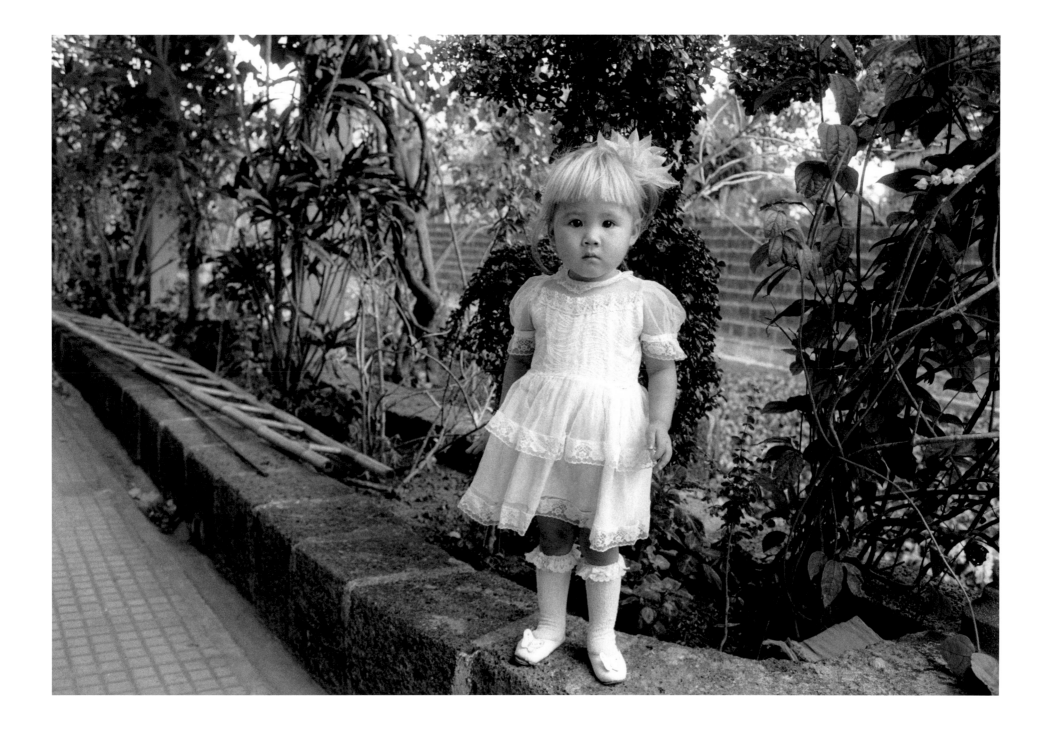

28 ▾ BOMB CRATER, XUAN LOC, 1992

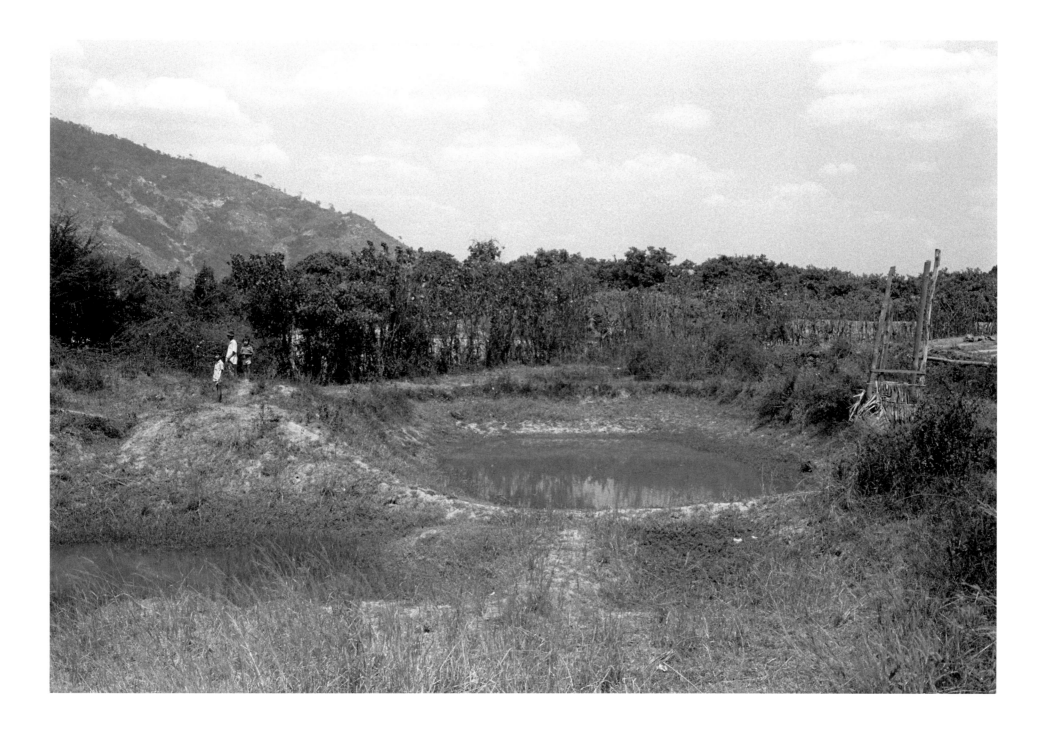

29 ▾ TICKETS, VINH MOC, 2004

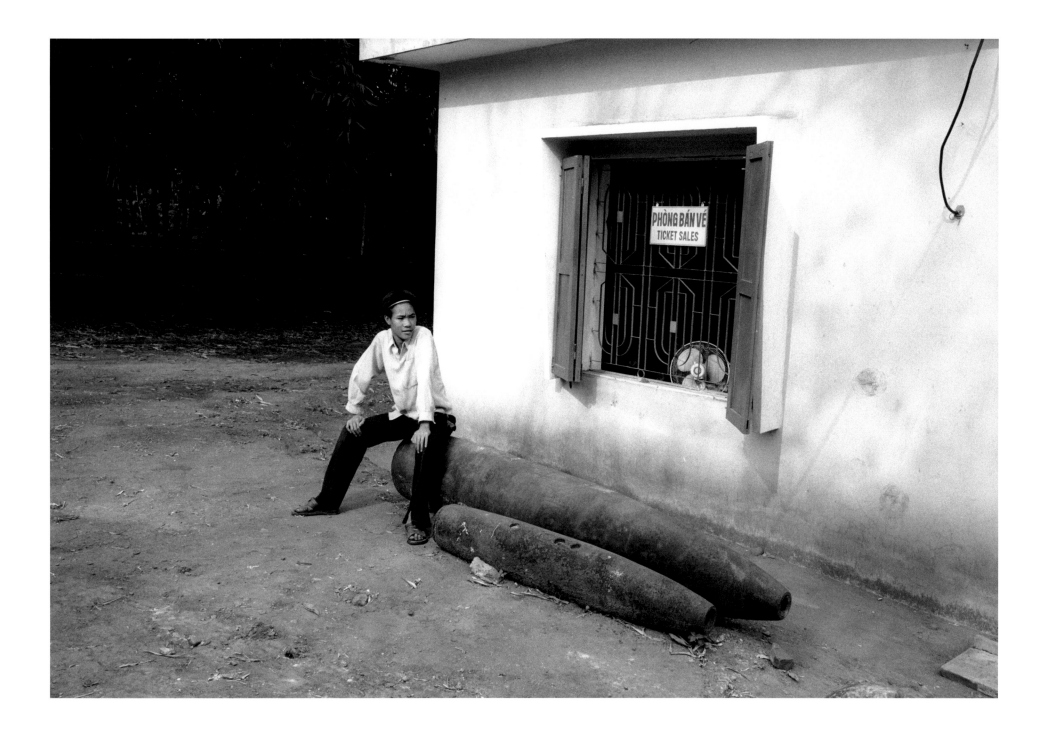

30 ▾ SPRING RAIN, 2004

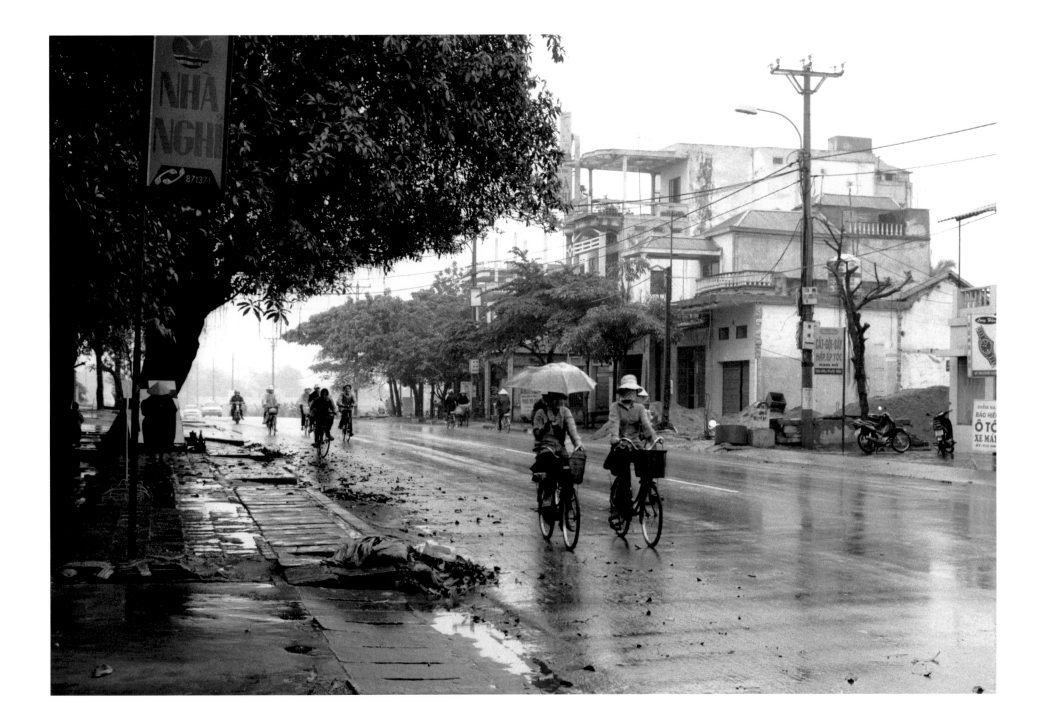

31 ▾ MOUNTAINS AND LAKE, 2004

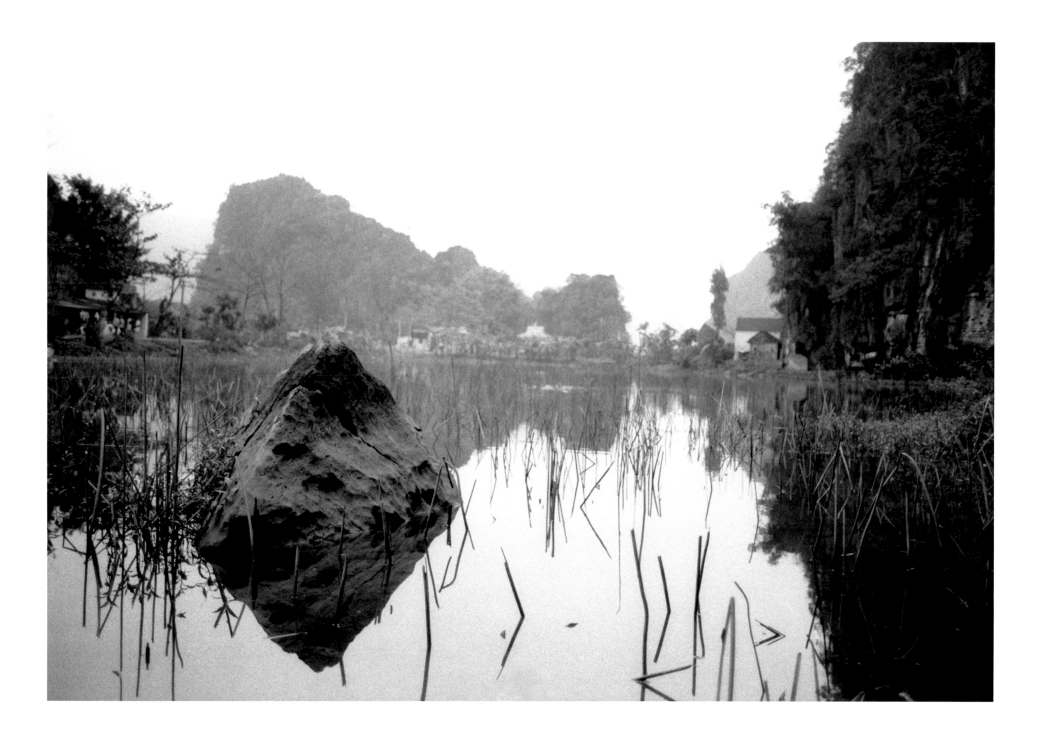

32 ▾ VILLAGE ROAD, 2004

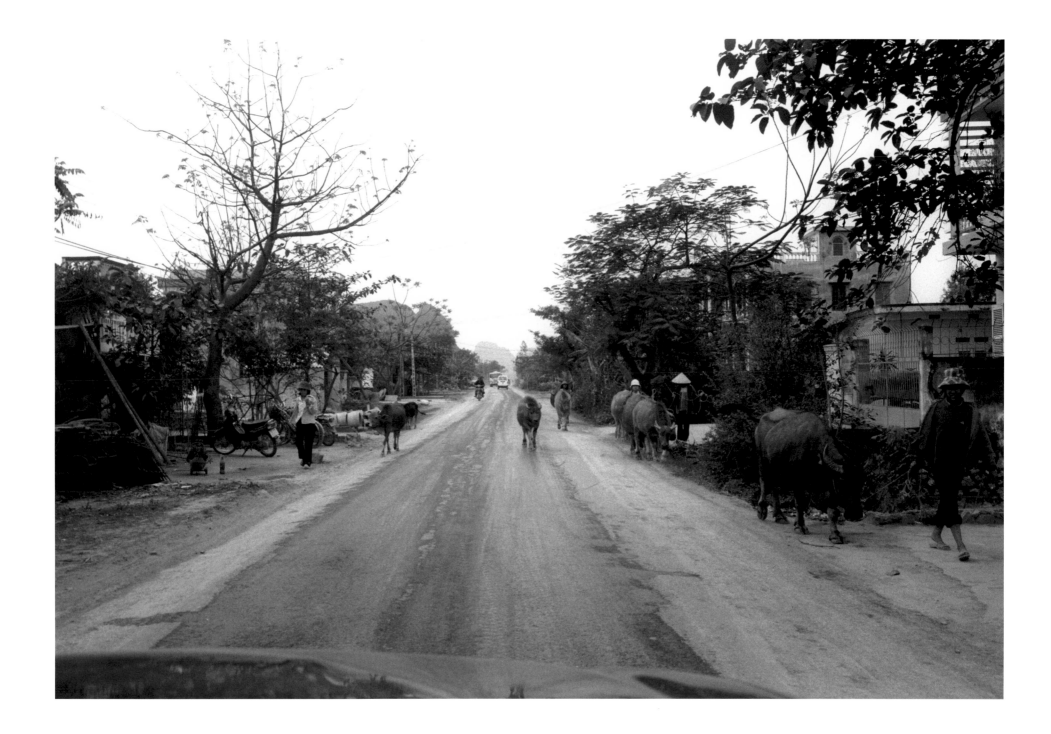

33 ▾ OPERA HOUSE, HA NOI, 1992

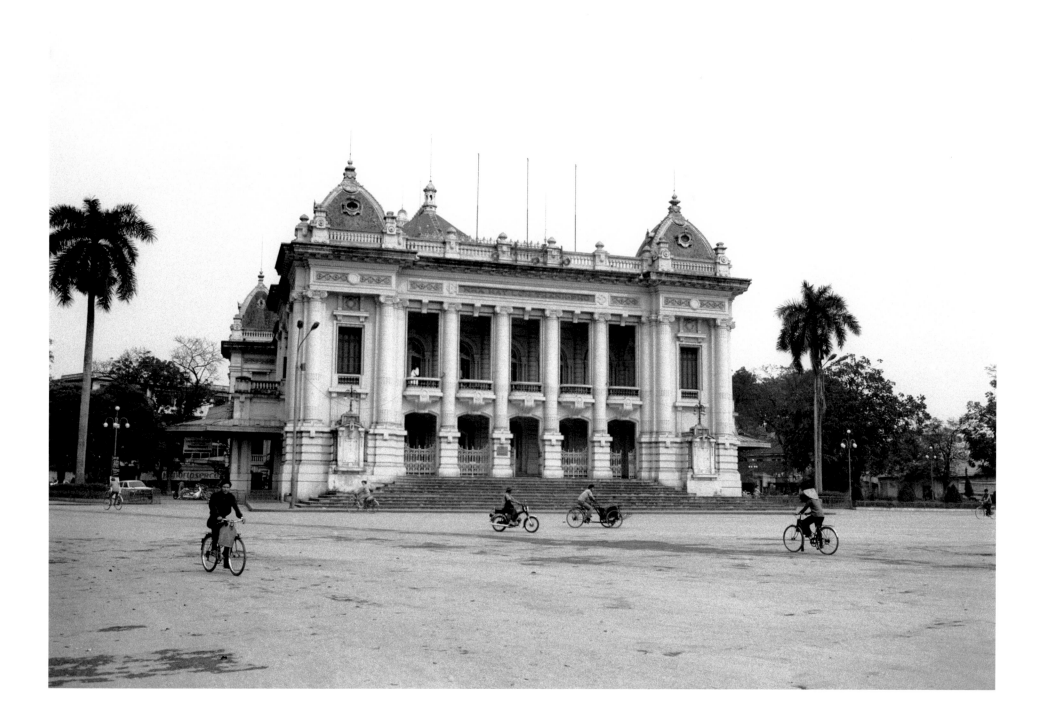

34 ▾ INTERSECTION, HA NOI, 1992

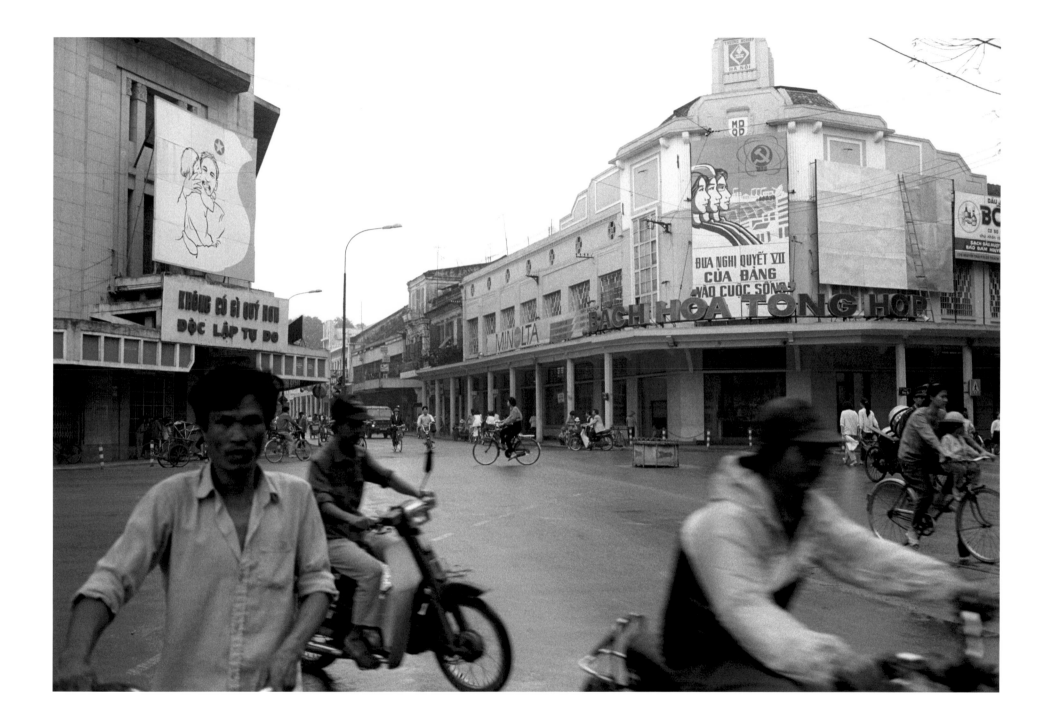

35 ▾ BILLBOARDS, HA NOI, 2001

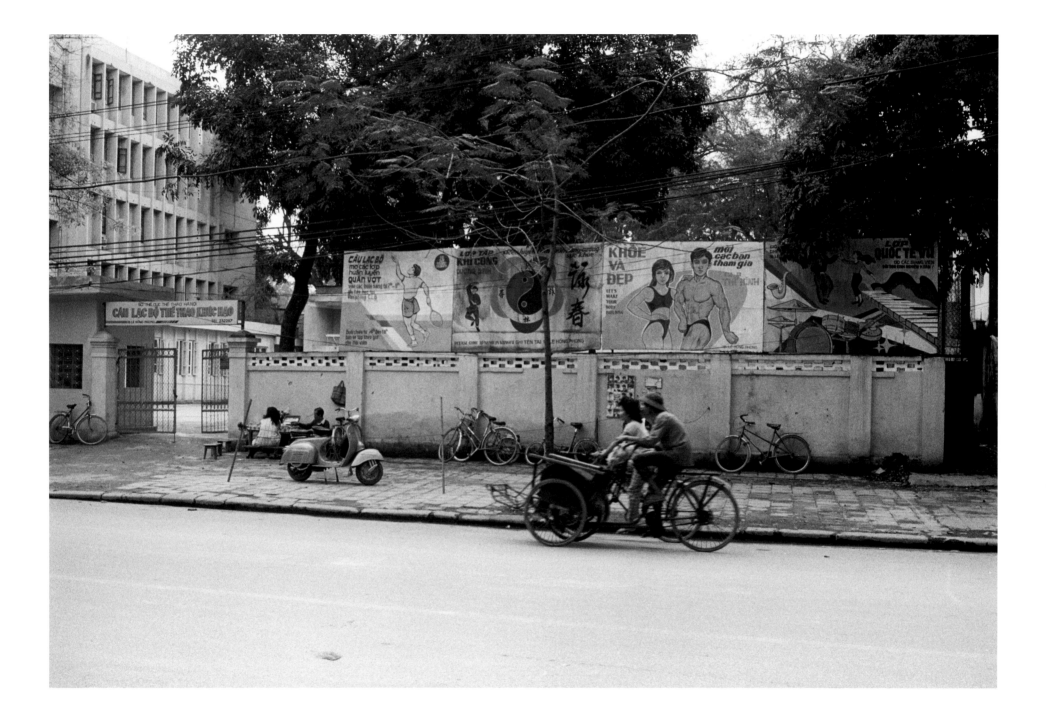

36 ▾ SUNDAY AT HO TRUC BACH (WHITE SILK LAKE), HA NOI, 1992

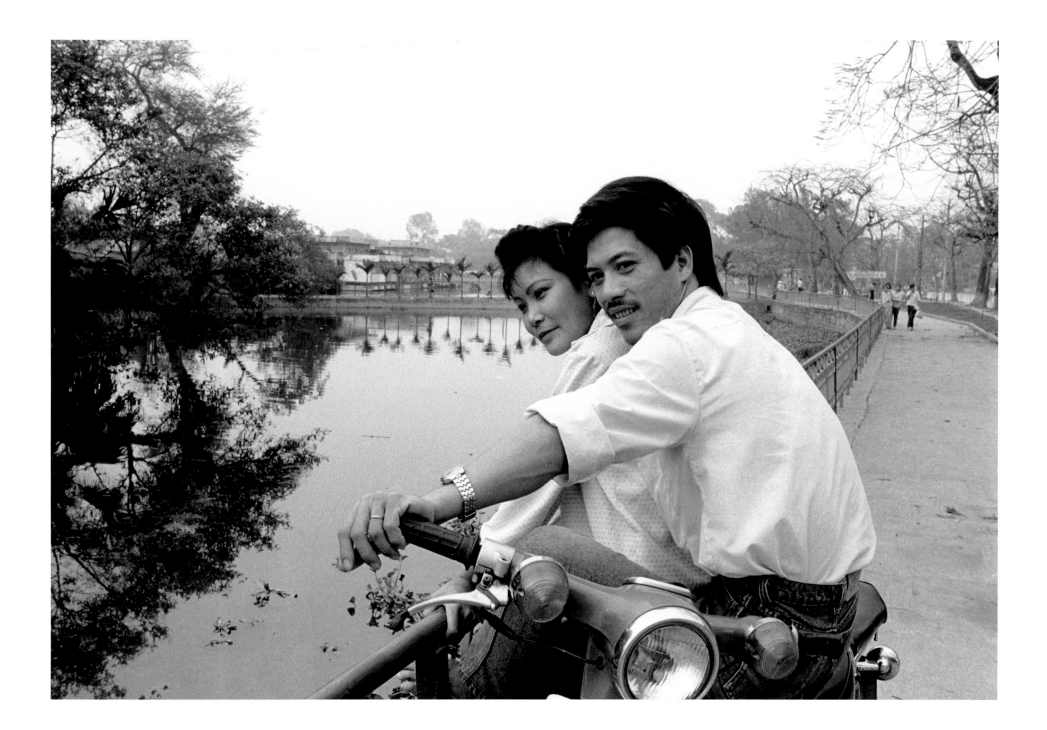

37 ▾ WAR REMNANT, HA NOI, 2000

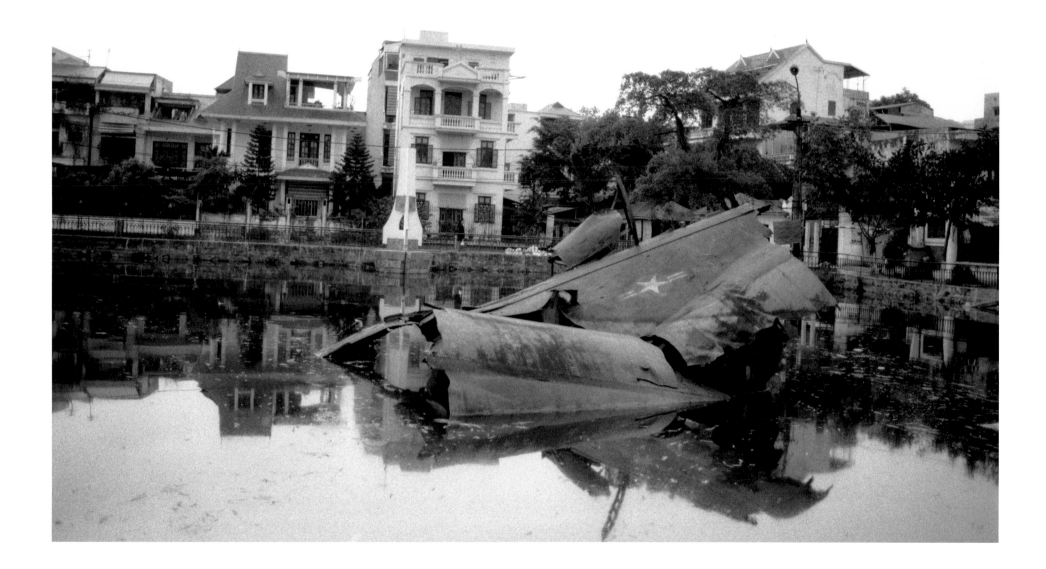

38 ▾ WAR MACHINES AND FRIENDLY COUPLE, HA NOI, 1992

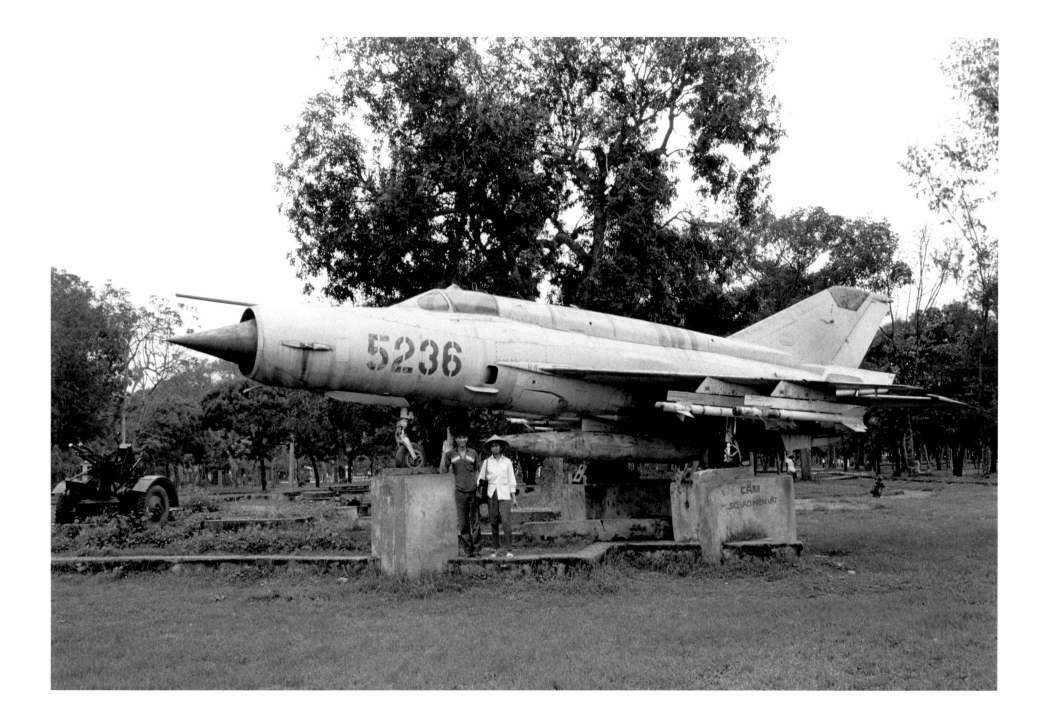

39 ▾ PLAYGROUND, HA NOI, 2000

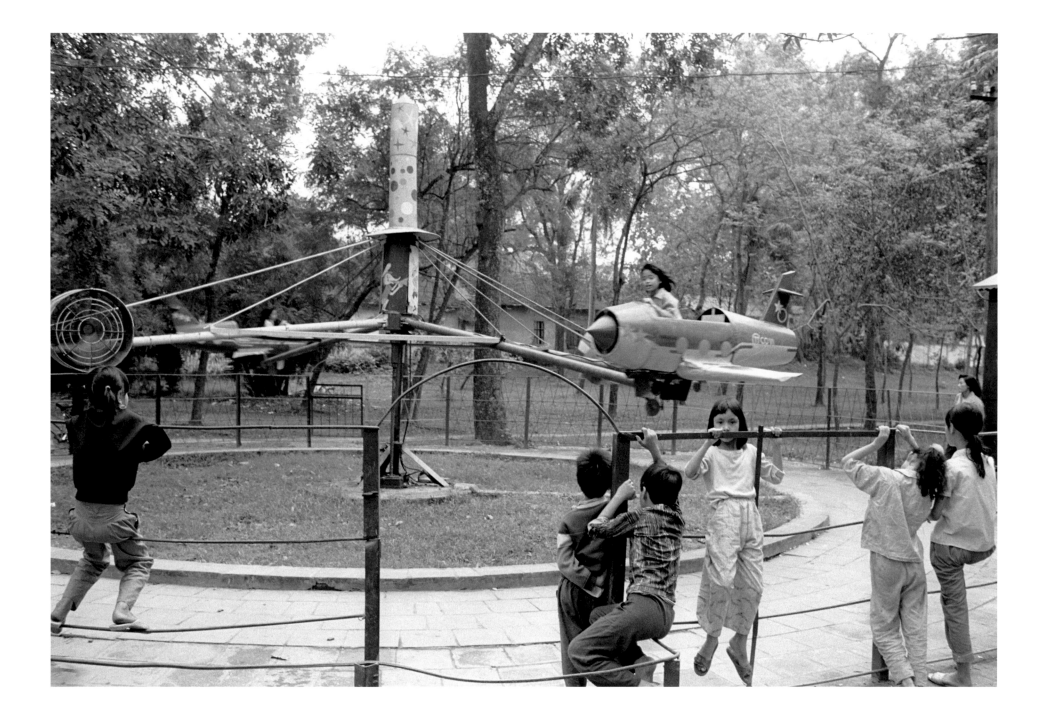

40 ▾ COCKFIGHT, HA NOI, 1992

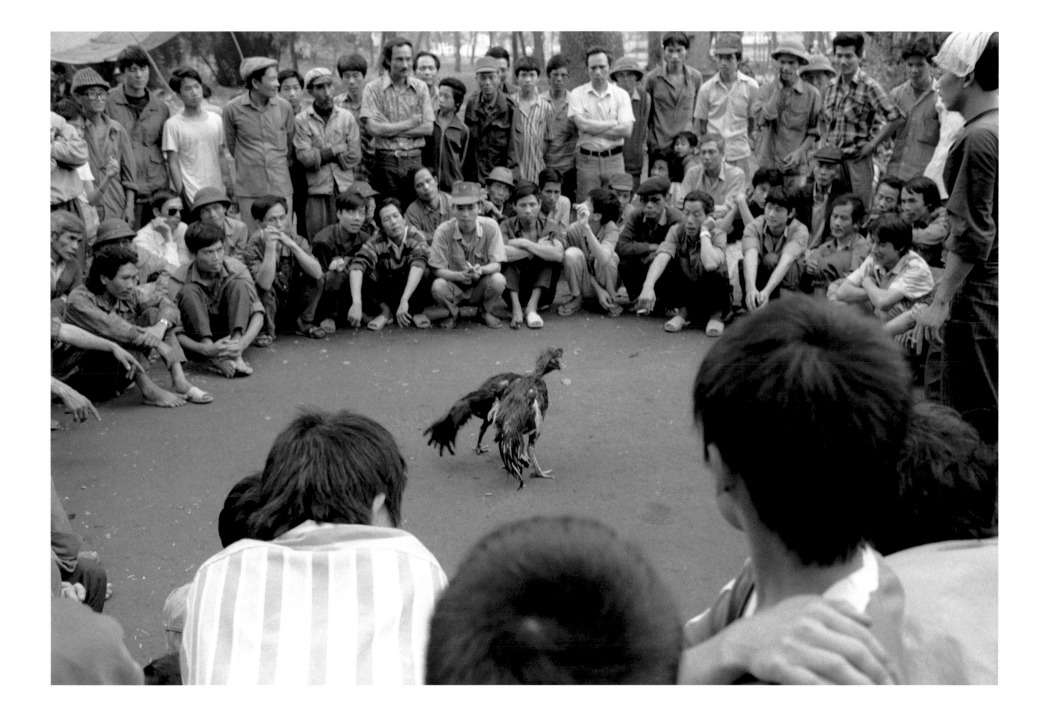

41 ▾ STREET MARKET, HA NOI, 1992

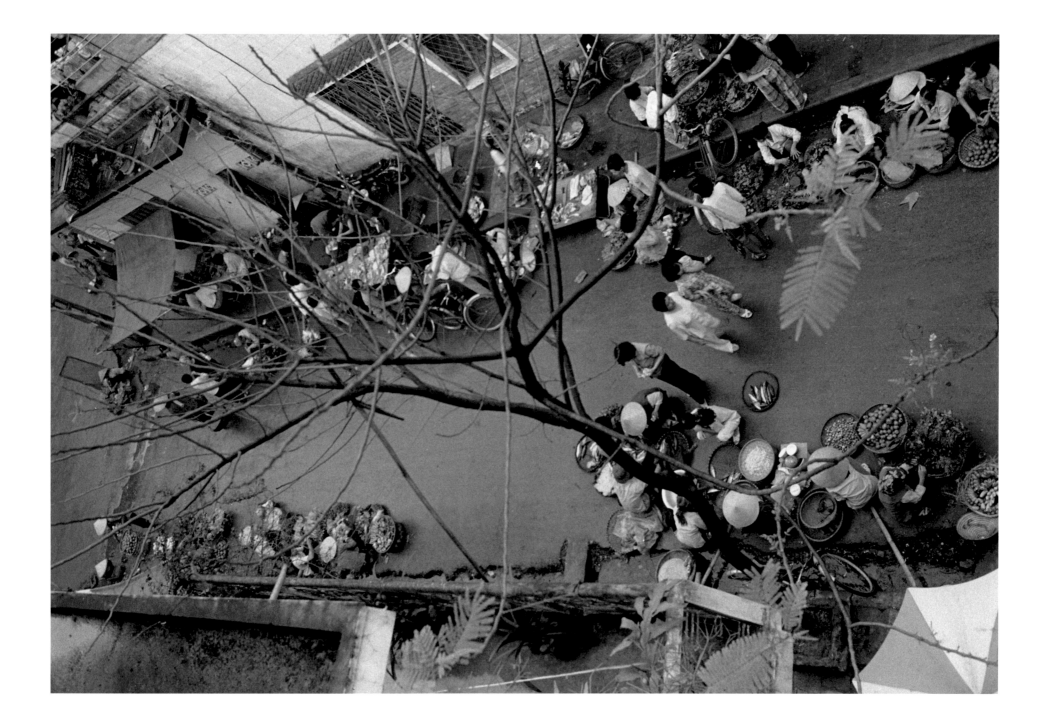

42 ▾ TEENAGERS, HA NOI, 1992

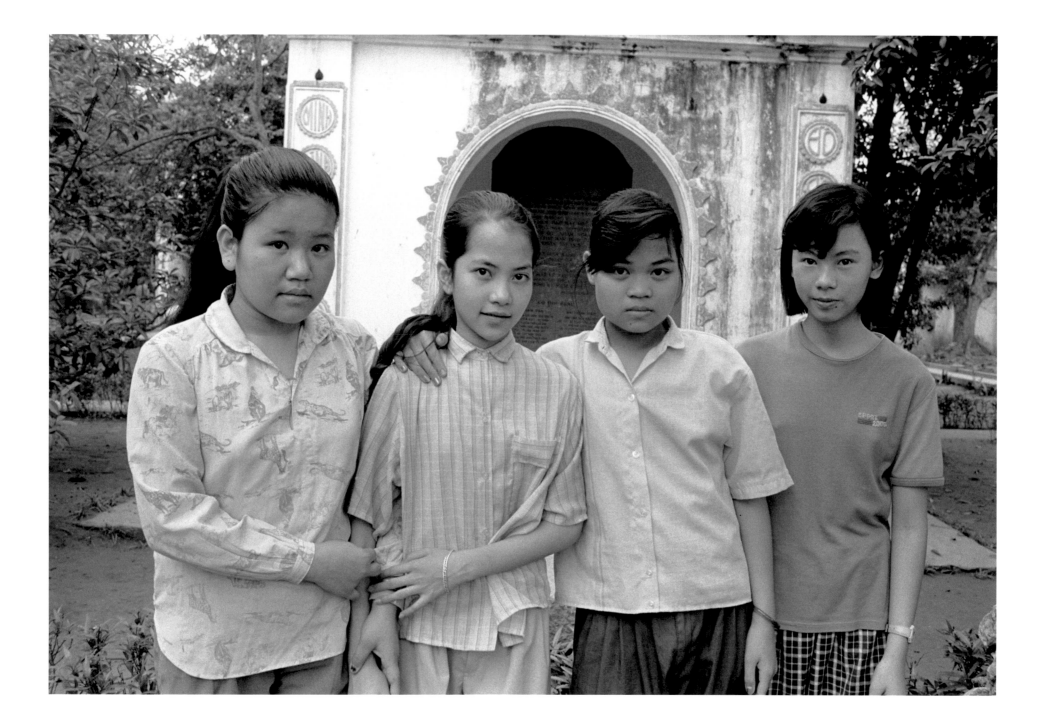

43 ▾ PORTRAIT STUDIO, HA NOI, 2004

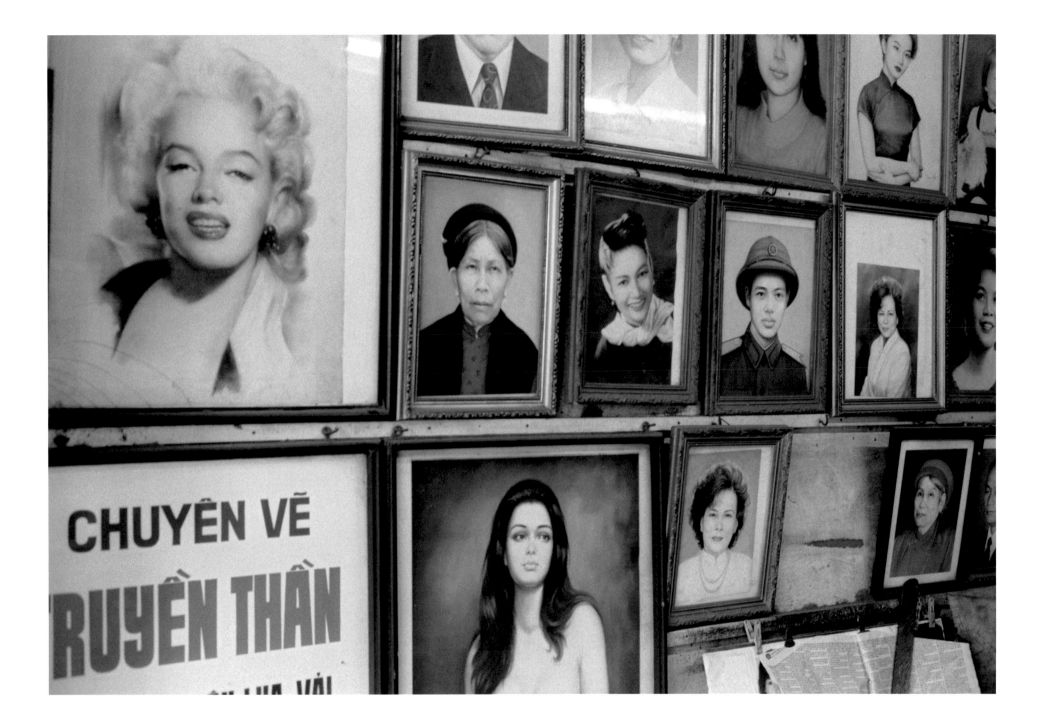

44 ▾ OLD WOMAN, HO HOAN KIEM (LAKE OF THE RESTORED SWORD), HA NOI, 2005

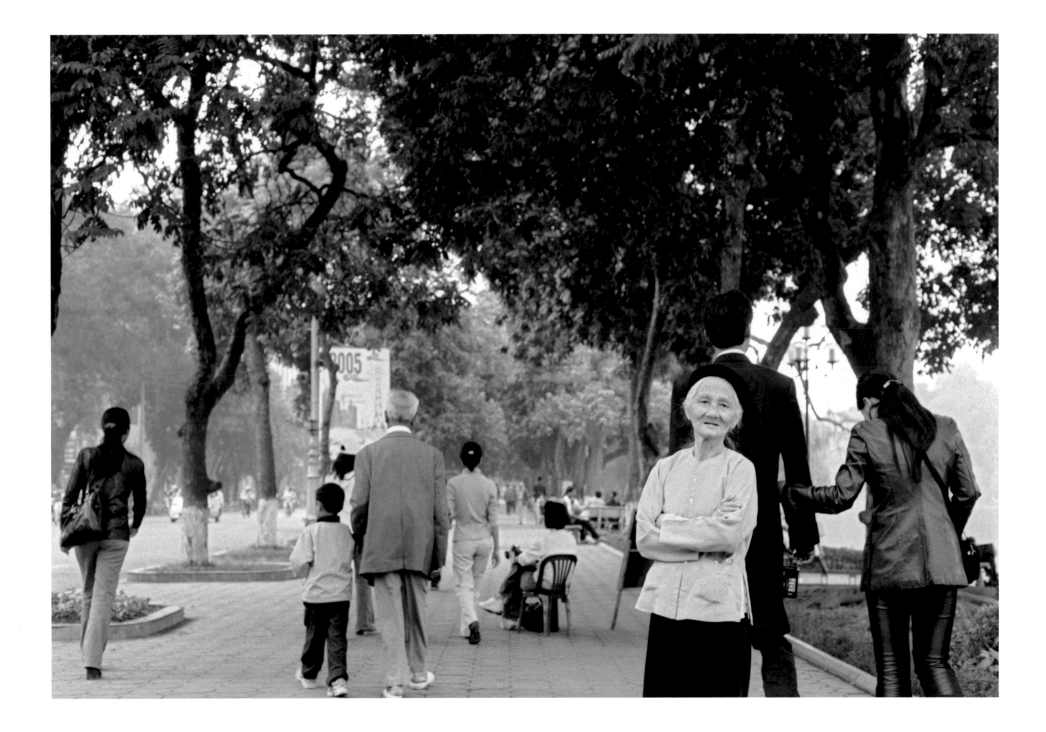

45 ▾ A NEW FLUTE, HA NOI, 2004

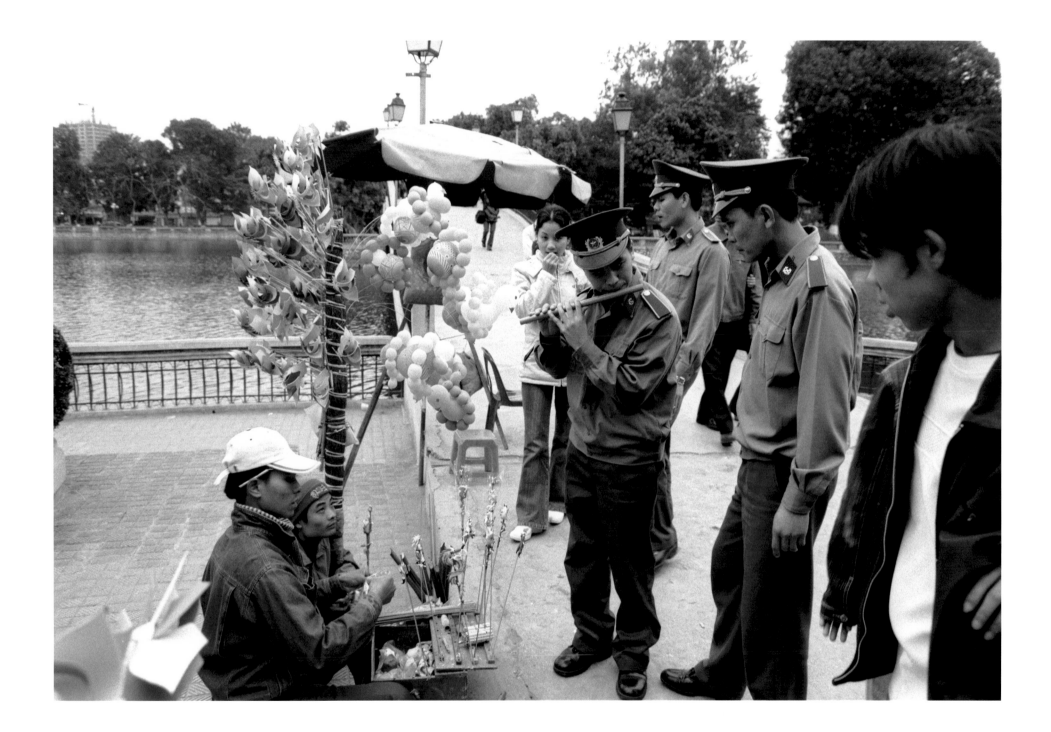

46 ▾ OPERA HOUSE AND HILTON, HA NOI, 2005

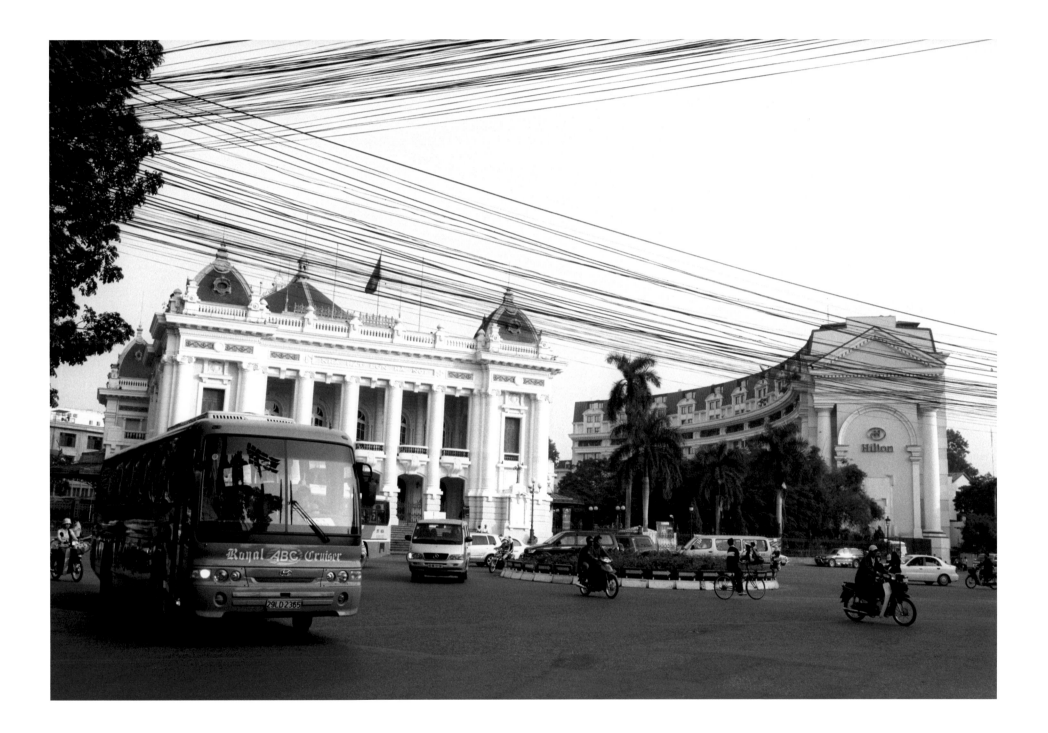

47 ▾ ARMY MUSEUM, HA NOI, 2005

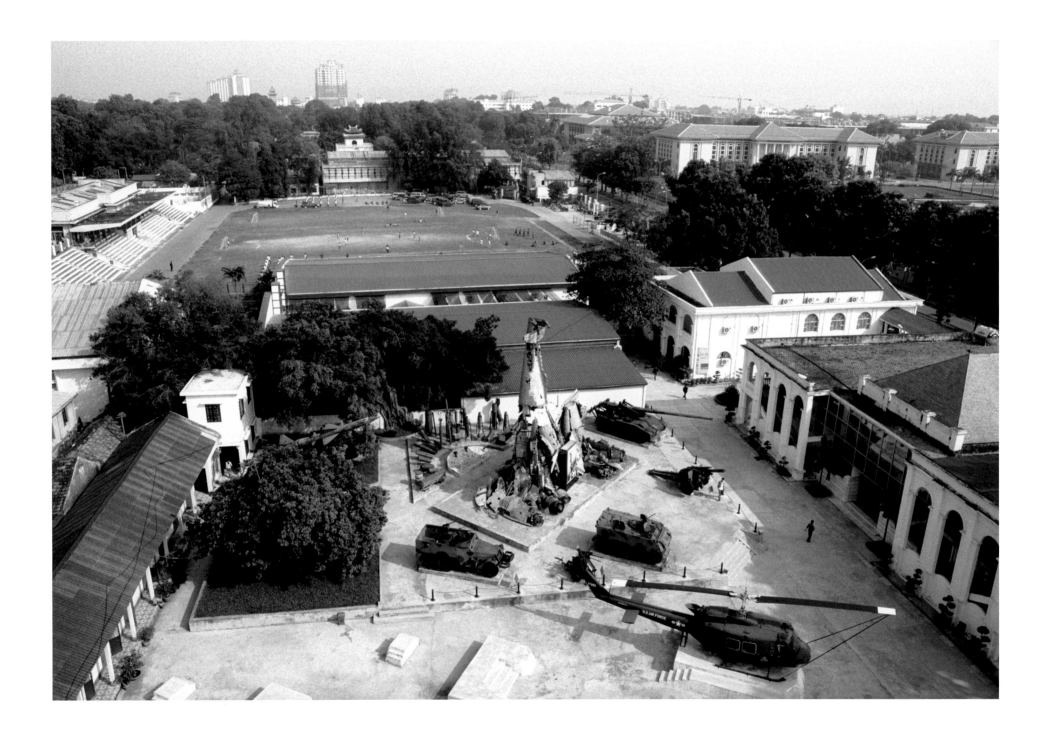

Acknowledgments

THE PHOTOGRAPHS AND BOOK that has come of them would not have happened without the support of my wife, Audrey. Her willingness to talk about and contemplate pictures encouraged me while working on *Spring Visits*. For that I owe immense gratitude. Also, I'd like to thank my daughter, Sonja, and my son Reuben, who I believe will only bring good to this world. To all of them, I am truly grateful.

There are many teachers to whom I am indebted, especially Drex Brooks, for his interest at the beginning. Phil Harris, Alexander Bloom and Nguyen Hong Phuong, deserve thanks for their kind words. Others have helped along the way, knowingly or not; they are, Fred Ritchin, Jeffrey Hoone and LIGHTWORK, Fred Marchant, Dennis Stovall, Tran Minh Hoang and Mike Boehm. Phil Bard, of Cirrus Digital Imaging, Portland, produced the image scans. In Seattle, Gary Hawkey and iocolor, provided prepress expertise and earnest support for this project. Kristina Kachele's design of *Spring Visits* is first rate and adeptly fulfills an idea. Durwood Ball and Kristen Sparks were thoughtful in editing text. Conversations with Charlie Clark, of Charlie Clark Books, helped to understand how this all works. Thanks to Copper Canyon Press, for permission to use *Spring-Watching Pavilion* and to poet John Balaban, for his translation of Ho Xuan Huong's artful poetry. In Viet Nam, I would like to thank Doan Duc Minh and Phan Van Do, whose assistance was indispensable and friendship greatly valued. The heroic photographer Lam Tan Tai, generously gave time to view photographs during his time of serious illness. Appreciation goes to Le Xuan Thang, Pham Kinh, Dao Hoa Nu and the Ho Chi Minh City Photographers Association for their support of an exhibition. My thanks to Nguyen Minh Quang, the friendly owner of Quang Linh Hotel, Ho Chi Minh City, who always had a room.

And to the people of Viet Nam, who were generous and welcoming, you have my admiration. Finally, to the TEENAGERS from Ha Noi, wherever you may be, I hope there is peace and happiness.

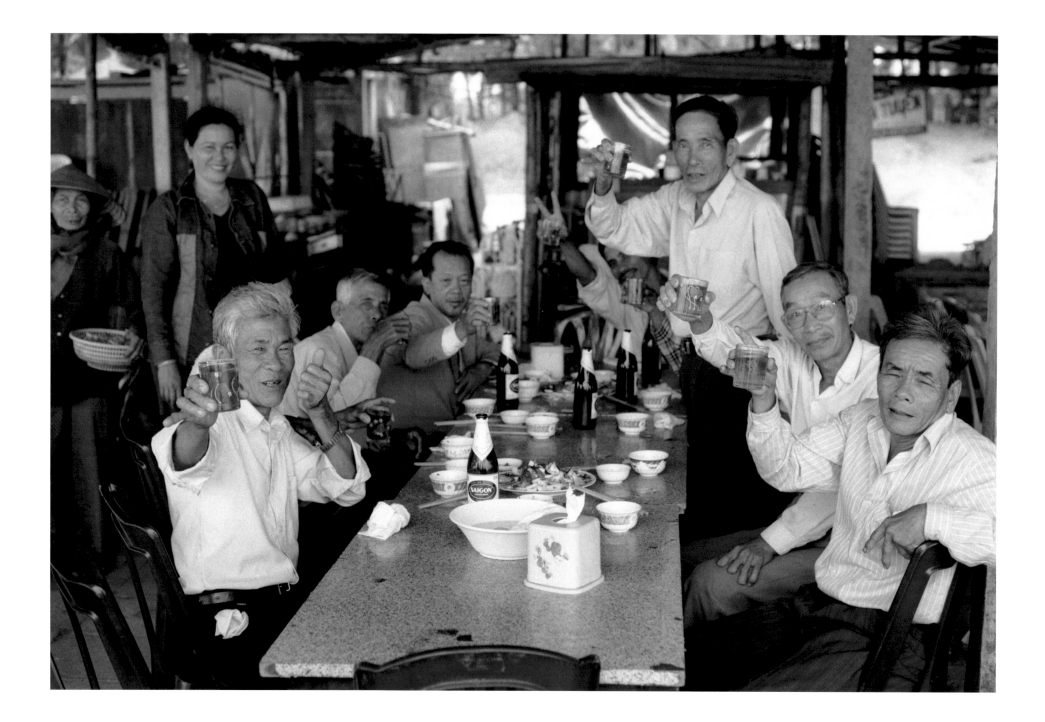

ISBN 978-0-9796490-0-4

Design by Kristina Kachele Design, llc, Albuquerque, New Mexico
Charlie Clark Books, Project Consultation
Prepress by iocolor, llp, Seattle, Washington
Printed in China by Shenzhen Artron Color Printing Co., Ltd on NPI matt art paper
Manufacturing supervision in China: Joseph J. Pasky, Cathay America
Ho Xuan Huong, *Spring-Watching Pavilion*, first published in *Spring Essence: The Poetry of Ho Xuan Huong*
(Port Townsend, Wash.: Copper Canyon Press, 2000), p. 115